Photography and the Body

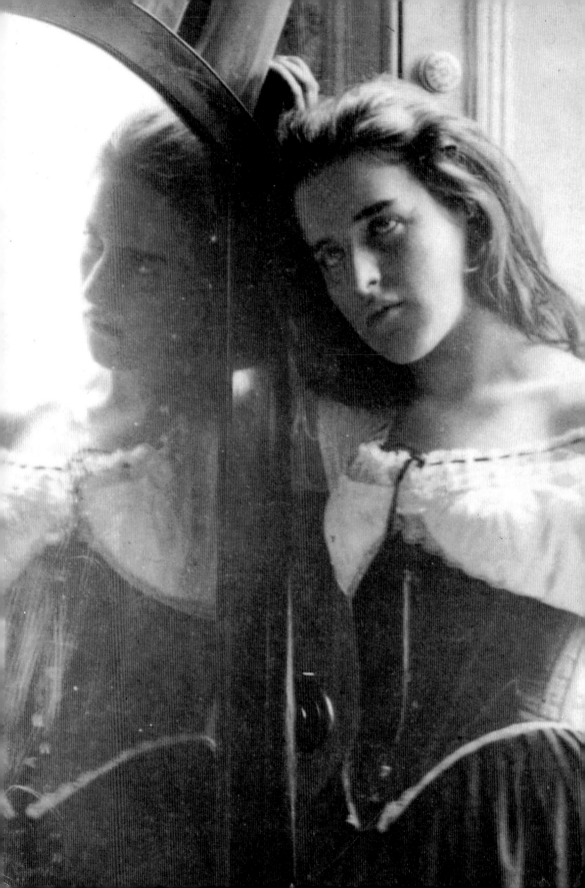

Photography and the Body

John Pultz

The Everyman Art Library

Acknowledgements

A great number of people have made this book possible and I have room to thank personally only a few of them. It goes without saying that I am indebted to the photographers, estates, galleries, and museums who provided the works illustrated in the text. For copies of photographs at the Spencer Museum of Art, I thank Robert Hickerson, museum photographer, and Midori Oka, registration intern.

Many of the ideas presented here were first developed in a graduate seminar on the body in photography that I held at the University of Kansas, spring 1994; my heartfelt thanks to its members for listening to a work in progress and for frankly sharing their ideas. Some of their insights appear here. For help at crucial points I thank Margaret Killeen, Michael Willis, and Bobbi Rahder. Finally, for reading and commenting on the manuscript I thank Julia Blaut and, as always, Susan Earle.

The project would not have been possible without the encouragement of Tim Barringer and Lesley Ripley Greenfield. I was fortunate to work with Jacky Colliss Harvey, an editor who managed to provide both constant support and a close, demanding reading of the text. Susan Bolsom-Morris, picture editor, was tireless in her efforts to obtain the best illustrations for this text.

First published in Great Britain in 1995 by
George Weidenfeld and Nicolson Ltd
The Orion Publishing Group
Orion House
5 Upper St Martin's Lane
London WC2H 9EA

A catalogue-in-publication record for this book is available from the British Library.

ISBN 0297 83363 4

Series Consultant Tim Barringer (Victoria and Albert Museum)
Designer Karen Stafford, DQP, London
Picture Editor Susan Bolsom-Morris
Printed and bound by Toppan, Singapore

Frontispiece CLEMENTINA, LADY HAWARDEN *Young Girl with Mirror Reflection*, page 42 (detail)

Contents

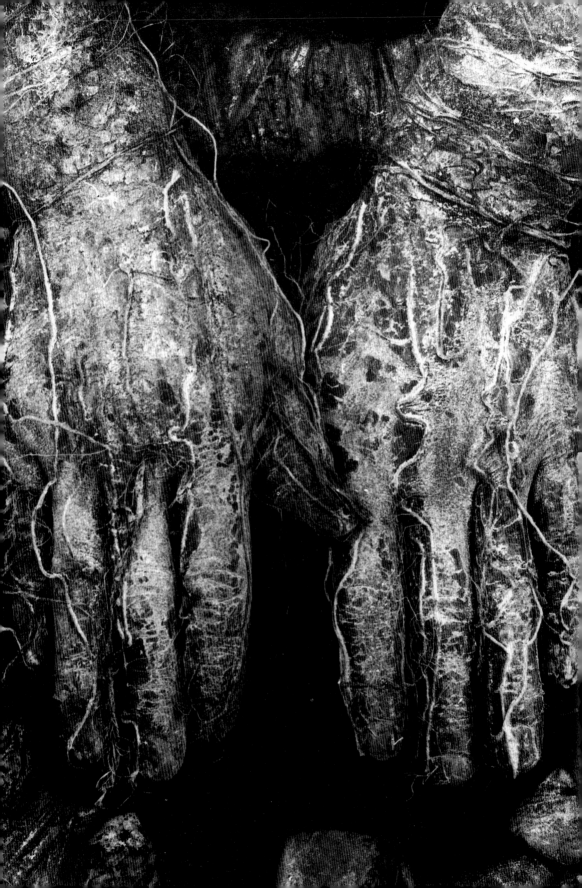

The Body in Photography

1. DIETER APPELT
(German, b. 1935)
Die Vergrasung der Handë,
1979. Gelatin-silver print, 11³/₈
x 15¹/₄" (29.1 x 38.9 cm).
Sander Gallery, New York.

T he emergence in recent years of postmodern and feminist thinking demands a reappraisal of how the body is represented in the visual arts. No longer a simple object of visual delight and innocent erotic delectation, the body is now understood to be the site of a highly charged debate. New theories insist that the representation of the body in the visual arts is central to society's construction not only of norms of sexual behavior but of power relationships in general. Asking how, and by what means, a body is represented produces more valuable answers than do stylistic analysis and connoisseurship.

This book examines how the human body has been represented by photography throughout the history of this most modern of all media in the visual arts. Photography has been the most widespread means of visual communication of the past century and a half, and has done more than any other medium to shape our notions of the body in modern times. This book investigates how photographic representations of the body shape and reflect not only obvious issues of personal identity, sexuality, gender, and sexual orientation but also issues of power, ideology, and politics.

Postmodern theory argues against essential definitions which assume that categories such as "male," "female," or "the body" are understood to mean the same things in all cultures or at all

periods. These terms are historically and culturally variable. Neither the body nor photography has any set meaning, any absolute or unchanging essence; rather the meaning of each is determined by social, historical, and cultural contexts. Therefore, the bodies discussed in this book are considered within their separate contexts. And unlike histories of photography that posit the existence of a unified subject – photography – that is essentially truthful, mechanical, and visual, this book considers photography as a wide variety of practices that have emerged since the medium's invention in the late 1830s.

As a critical re-examination of photography based in postmodern theory, this text will in many places seem to invert center and margin. It reconsiders photographs that are well known and introduces less familiar ones, moving between those made as "art" and those made as documents. In rejecting a formalist history of art which looks at photographs in isolation, tracing developments of style and technique, this book assumes a methodology that is pluralistic, drawing as appropriate on ideas from Marxism to the psychoanalytical theories of Freud and Lacan, and on methods taken from anthropology, literature, history, and sociology, as well as art history.

In the process of surveying how the body has been presented in photography, this book will begin untangling photography from the Modernist rhetoric that has been used to define it throughout its history. Photography and Modernism grew up together; as an industrial product, photography stands as a metonym for the industrialization that defines the modern era.

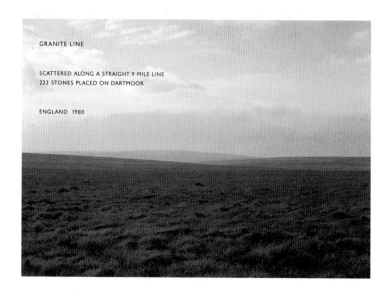

GRANITE LINE

SCATTERED ALONG A STRAIGHT 9 MILE LINE
223 STONES PLACED ON DARTMOOR

ENGLAND 1980

2. RICHARD LONG
(British, b. 1945).
Granite Line (Scattered along a straight 9 mile line 223 stones placed on Dartmoor), 1980.

Photography is also a metonym for the Enlightenment, the philosophical thinking that arose in the eighteenth century and that has dominated the Modern era. The Enlightenment valued empiricism, the belief that experience, especially of the senses, is the only source of knowledge. Photography seemed the perfect Enlightenment tool, functioning like human sight to offer empirical knowledge mechanically, objectively, without thought or emotion. The existence of photography also buttressed the Enlightenment account of the coherent individual, or subject. A whole series of relationships within the photographic process – camera to subject, lens to film, observer to photograph – reproduce the position of a privileged, unique Enlightenment subject: the observer apart, freely viewing some object or scene.

The writing of the French historian and philosopher Michel Foucault (1926-1984), who has led the critique of Enlightenment thinking, suggests a means to separate photography from the rhetoric of Modernism. In his books Foucault explored major social institutions created in the nineteenth century: psychiatry (in *Madness and Civilization*), medicine (in *The Birth of the Clinic*), and criminal justice (in *Discipline and Punish*). He concluded that these building blocks of a presumably free and liberal society were actually subtle means of social control. The control exerted by these institutions suggested to him that the free, unique Enlightenment individual was a mythical character who never existed. Foucault refused to refer to persons as "individuals," calling them instead "subjects," to convey the degree to which they are subject to (and constructed by) these means of social control.

Foucault found instruments of control throughout society, and his writings suggest that photography was one of the means of establishing and maintaining power. Rather than us freely using photography as a tool under our control, his writings would suggest that photography controls us, with the images produced through it becoming additional means of control.

Foucault further asserted that power produced knowledge (not vice versa), and that without free individuals there could be no impartial knowledge. Rather, all knowledge is the product of power because everyone is subject to social control. There was for Foucault no viewpoint from which one could make objective observations; all vantages were affected by power. If Foucault's relationship of knowledge to power is accepted, the knowledge produced by photography cannot be disinterested, rational, and neutral. Instead that knowledge, and the means of its production, constitute what the Italian communist theoretician

Antonio Gramsci (1891-1937) would call an "apparatus of ideology," used by a ruling class to establish and maintain its cultural hegemony. Both Foucault and Marxist critics have argued this position.

Photography was invented at a period of social conflict throughout Europe and America, when a series of proletarian uprisings convinced the bourgeoisie and aristocracy that the capitalist system upon which they depended required social stability. The British art-historian and photographer John Tagg (b. 1949) argues that photography, born out of the mass culture that came into being following the revolutions of the late eighteenth century, existed first as a means of celebrating the individual and then as a means of social control.

The writings of Foucault, Gramsci, and Tagg suggest that we reject the idea that photography is an objective medium, in the service of a free and liberal society. This book follows their lead, and sees photography not as an innocent tool but rather as an active means by which society is structured. Their writings urge us to see photography as implicated in a whole series of power relationships that exist within society, especially those of gender, race, and class. These ideas will dominate the text but will be developed in consideration of specific photographs in specific contexts.

Chapter One explores how, from their first appearance, photographic representations of the human body have been intertwined with power relationships and social control. This is seen in law-enforcement, ethnographic, and surveillance photographs, and in photographic studies of criminals and the insane, all of which serve to define societal norms. Chapter Two uses feminist theory to consider social control and the fabrication of patriarchal structures through both aberrant and seemingly "normal" representations of women.

Chapter Three looks first at nudes made by American photographers, who created nudes at once enticing and cold, then at the work of European Modernist photographers, who took a less puritanical view of the body than did their American counterparts. European photographers anticipated postmodern acts of deconstruction, revealing the very process by which the body is photographed.

In Chapter Four the body is examined as a symbol of social disorder in the twentieth-century documentary tradition, where it is used to fabricate symbolic responses to specific ideologies. The "documentary" body is contrasted with works that subvert the early Modernist presentation of the body, altering it through

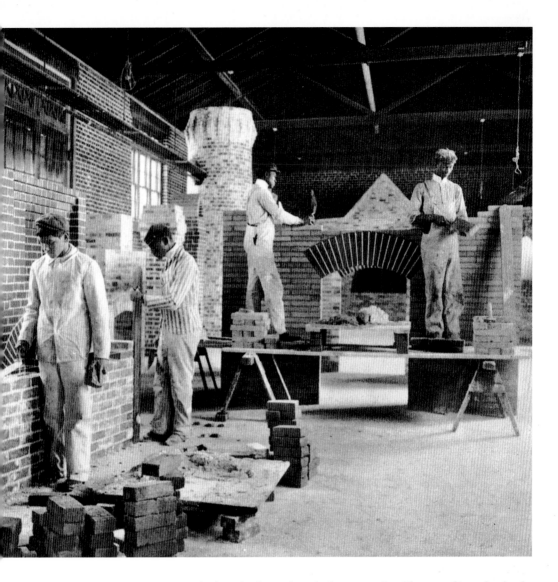

3. Frances Benjamin Johnston
(American, 1864-1952)
*Trade School, Brick Laying,
Hampton Institute*, 1899-
1900. Platinum print. Library
of Congress, Washington,
D.C.

optical and photochemical means. In Chapter five, the body
moves to the center of new art, with a new consciousness of
how it can be manipulated. The actual act of performance often
becomes the art object, with photography as its documentation.

Chapter Six considers photographers who use the highly
purified formalist language of Modernism, but apply it to more
self-consciously problematic subjects. In their work, bodies are
socially connected, entering clearly defined social discourses at
the time of their making. These photographs are explicitly polit-
ical, dealing with problematic sexuality and notions of self-
identity. Most of these photographers act out assumed or fictive
roles; they refuse to seek any "true" or "real" self.

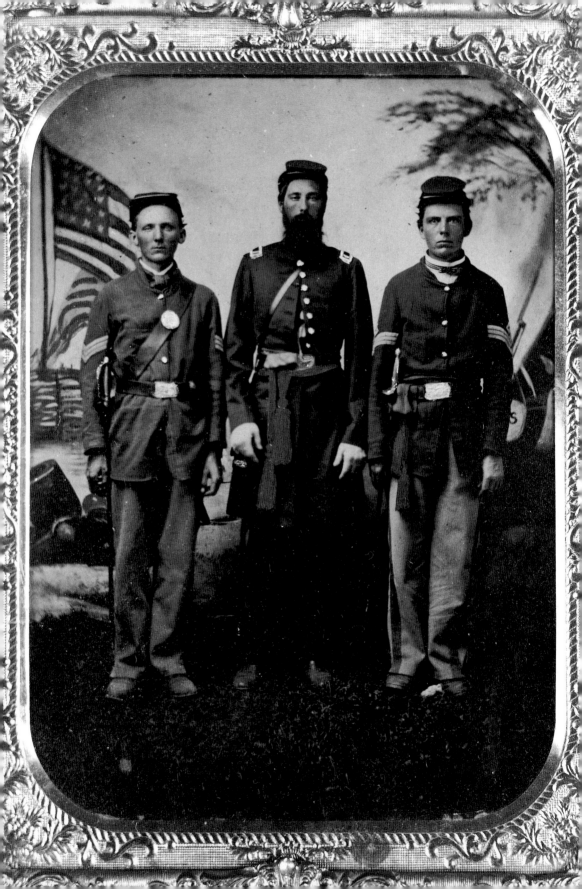

The Nineteenth Century: Realism and Social Control

Photography and the body first intersected in the production of portraits. Before photography, how one had one's portrait made was an indication of social class: a portrait from a painter or draftsman cost more money than one from a silhouette cutter or a limner (artisans who made cheap painted portraits characterized by hard edges and unmodulated tones). Most people, even in the industrialized countries of Europe and North America, never saw, held, or owned visual representations of their own bodies. A succession of new techniques, however, evolving from the late 1830s through the 1850s, made photographic portraits less and less expensive. People who previously had been unable to have their portraits made at all, or had to rely on crude likenesses made by silhouette cutters and limners, came increasingly to be able to afford fully detailed portraits.

The First Photographic Portraits

The first widespread photographic technology applied to portraiture was the daguerreotype (FIG. 4). Invented in 1838 by Louis-Jacques-Mandé Daguerre, the French maker of dioramas (vivid illusions of reality produced through the use of three-dimensional scale models, cloth transparencies, and controlled lighting), these delicate images were laid down by mercury vapor on metal with such clarity that they were sometimes dubbed "mirrors with a memory." Daguerreotype photography

4. PHOTOGRAPHER UNKNOWN Untitled (Portrait of three men in Civil War uniforms), 1861. Daguerreotype 5¹/₂ x 4¹/₄" (14 x 10.8 cm). Spencer Museum of Art, University of Kansas.

was seen as requiring technical rather than artistic skill, and few of its practitioners had the conventional fine-art training that would have aligned their work with high-art models; most daguerreotypists labored as artisans, producing straightforward, vernacular portraits, unmediated by any sophisticated conventions of representation and bearing no meaning beyond their obvious realism. Stylistically, these portraits seem to be the natural result of technical competence and efficient production. They are mechanomorphic – that is, they reproduce in their style the mechanical means of their production: plain, empty backgrounds suggest the artificial, antiseptic space of a work-shop or laboratory. The self-consciousness of these empty spaces becomes apparent when such portraits are compared to studio work, in which painted backdrops depicting drapery, columns, distant views, and other conventions of painted portraiture since the Renaissance are widely used. Photographic portraits that forgo the use of props present the body without narrative or iconographic guises to elevate it. The body, represented in its purely material physicality, gains a power of its own.

To have one's self portrayed was a sign of individual importance. While we recognize handmade portraits as either literal, symbolic, or a mixture of the two, we take photographic portraits to be mostly literal, and enjoy them for their power to make an absent or dead person seem present. But realistic attention to detail in daguerreotype portraiture was itself symbolic, representing the individualism of the Enlightenment. Even the most rudimentary daguerreotype said that the body it depicted was unique, requiring the specific, literal representation that photography offered to set it apart from all other bodies.

The situating of a body within the space of a picture can also define the viewer's relationship to it. The Scottish painter David Octavius Hill and the photographer Robert Adamson collaborated on portraits and genre scenes which moved the body from the vacant space found in early photographic portraits to one occupied by other beings, thus providing a social context. Hill and Adamson used the calotype process. This yielded paper negatives from which countless prints could be made, a clear advantage over the daguerreotype process, which produced only a single original positive from each exposure. However, calotypes were much less sharp than daguerreotypes, because the paper fibers diffused light passing through the negatives in the printing process. Hill and Adamson took advantage of the fact that calotypes described more through tonal effect than through detail, and made their pictures seem more artistic by modeling them

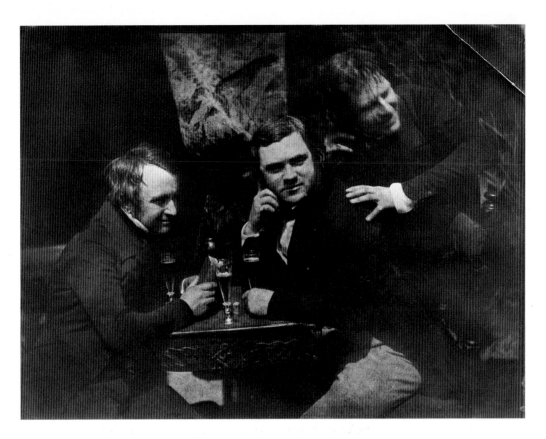

after the heavily shadowed art of the seventeenth-century Dutch painter Rembrandt van Rijn. Hill and Adamson drew also on Rembrandt's conventions of group portraits to arrange individuals into seemingly naturalistic scenes, as in *Edinburgh Ale* (FIG. 5). The men represented here, including Hill on the right, interact with each other in easy affability.

In 1851 the English sculptor Frederick Scott Archer found that by using collodion (a syrupy solution of extreme stickiness) he could make photosensitive silver salts adhere to nonporous materials such as glass and metal. Within a few years of Scott Archer's discovery, collodion was being used to make direct positive images on thin sheets of iron (known as "ferrotypes" in France, "tintypes" in Great Britain and the United States) and on glass ("ambrotypes" in the United States, "amphipositives" in France, and "collodion positives" in Great Britain). These were even less expensive to produce than daguerreotypes, and ambrotype and tintype portraits became especially popular in the United States in the late 1850s (FIG. 6). Collodion could also be used to produce negatives on glass, which yielded clearer prints than any made from the paper negatives of the calotype

5. ROBERT ADAMSON (Scottish, 1802-1870) and DAVID OCTAVIUS HILL (Scottish, 1821-1848) *Edinburgh Ale* (James Ballantyne, Dr. George Bell, and D.O. Hill), c. 1845. Carbon print from original calotype negative by Jessie Bertram, 1916, 6¼ x 8¼" (15.7 x 20.8 cm). Spencer Museum of Art, University of Kansas.

6. PHOTOGRAPHER UNKNOWN Untitled (Nineteenth-century portrait). Hand-colored tintype 1¾ x 1½" (4.5 x 3.8 cm). Spencer Museum of Art, University of Kansas.

process. These glass negatives were printed on another invention of the 1850s, albumen paper, which used egg white to make the porous surface of paper hard and smooth. Combined, the new technologies of the glass negative and albumen-silver paper made widespread commercial photography possible for the first time.

The Spread of Portraiture

Two formats seized the public imagination and became the first truly mass-produced forms of photography. The stereographic card, when used with a special viewer, combined two images to produce the illusion of three dimensions. It was mostly used for urban scenes and landscapes. The carte-de-visite, on the other hand, was used for portraits. Patented in 1854 by the French photographer André A. E. Disdéri, the process of making them used a multi-lens camera and a moving film-holder to produce from a single glass-plate negative six to twelve albumen-silver

prints. They measured $2^1/_2$ x $3^1/_2$ inches and were mounted on heavy card. Because photographers could now make as many as twelve prints at once, the retail price of photographic portraits came down markedly, making them at last accessible to the mass of people. In fact, as one of the most widely marketed of the new consumer goods of the nineteenth century, the carte-de-visite helped to define and record the "masses" as an entity.

As portraiture became more accessible and more common, the status of the human body within society changed. Another body, beyond that defined by the daguerreotype and calotype portrait as the individual, was produced through the invention of the carte-de-visite – the collective body of the middle class. Conventional histories suggest that photography was invented to meet the demands of a growing middle class for cheap portraits. Marxist historians challenge this assumption, arguing that the middle class of the mid-nineteenth century was not a coherent entity with clearly defined pre-existing needs, but rather a series of ever-changing aggregations formed in the pursuit of common goals or as the result of shared beliefs or practices. Carte-de-visite photography, these historians argue, was one of the practices that defined the new bourgeoisie. Moreover, it produced images so cheap and common that they accumulated into a collective portrait of that class.

The widespread availability of cheap portraits gave the body a life apart from its actual physical presence. Carte photography extended to many more people in society than ever before the symbolic power to manipulate people through their images, a power previously reserved to the classes that could commission or buy portraits produced by painting, drawing, or the traditional graphic arts. Using a carte as a calling card, one left behind the photographic trace of the body. Friends collected these portraits into albums which were being manufactured and marketed specifically for the purpose by 1860. Collections of portraits became substitutes for collections of real people, whether families, armies, or public figures. Cartes of the latter could be purchased from commercial photographers, in shops or by mail. Napoleon III, Abraham Lincoln, Queen Victoria, and Albert, the Prince Consort – persons at the upper reaches of the economic and political hierarchies, who had always had access to finely made handcrafted portraits – found it politically expedient to be portrayed in mass-marketed photographs. Cartes and albums functioned in the same way as the tight cropping and positioning in Hill and Adamson's picture, to make unknown persons as accessible as good friends. Albums made the world a

place where the bodies of family, friends, celebrities, or political figures seemed equal. However, this democratic inclusivity had its limits. Not included in the albums were people marginalized or excluded from middle-class life itself, such as the poor and the sick.

The widespread affordability of tintypes and cartes-de-visite also made photography a means of holding families together amidst the rapid transformation of European and American society in the nineteenth century, as individuals and families moved from countryside to city and from Europe to America. Tintypes and cartes were lightweight, thin, and especially well-suited to be posted through the mail. They substituted for expensive or impossible visits. In the early 1860s, during the American Civil War, tintype photography provided portraits of young sons and husbands going off to fight, affording memories of loved ones who might not return alive. As the middle-class family gained social and economic importance, photographs afforded a visual record of its existence from one generation to the next, performing the same function that painted portraits had fulfilled for centuries for aristocratic families.

Owning cheap carte-de-visite photographs was one way to "see" the bodies of public notables otherwise only read or heard about. Before the age of cinema, portraits of stage actors took on additional significance, providing direct, intimate knowledge of the actor's face and body. *Sarah Bernhardt as Frou-Frou* by Napoleon Sarony (FIG. 7) served just such a purpose. A maker of sentimental lithographs during the Civil War, Sarony subsequently learned photography and became the American master of theatrical photographic portraits. He nurtured (and profited from) the cult of personality that accompanied the golden age of theater in the three decades of economic prosperity following the war. Sarony paid $1500 for the exclusive rights to make and market photographs of Bernhardt, often showing her in specific dramatic roles.

Like the theatrical portraits of the eighteenth-century British artists Joshua Reynolds, Thomas Lawrence, and Thomas Gainsborough, Sarony's photograph, in depicting the enactment of a dramatic role, is raised from the lowly status accorded portraiture in the hierarchy of the genres to the more elevated realm of allegory. It is noticeable that artists have always tended to allegorize female sitters more frequently than males. Reynolds himself produced some of his most noted works in this genre, suggesting that he, among many other artists, viewed the female body as more open than the male to this act of appropriation.

JOSHUA REYNOLDS
Sarah Siddons as the Tragic Muse, 1784. Oil on canvas, 7'9" x 4'9" (2.3 x 1.4 m). Henry E. Huntington Library and Art Gallery, San Marino CA.

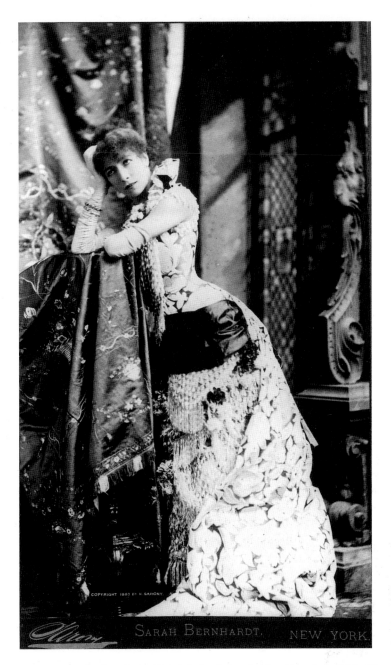

SARAH BERNHARDT. NEW YORK.

7. NAPOLÉON SARONY (American, b. Canada, 1821-1896). *Sarah Bernhardt as Frou-Frou,* 1880. Albumen print, 12 x 7¹/₄" (30.6 x 18.3 cm). Cincinnati Art Museum.

Sarony presents Sarah Bernhardt as the eponymous lead from Meilhac and Helévy's drama *Frou-Frou,* which was then touring in the United States. The play harshly judges independent women, presenting Frou-Frou as a social butterfly active in the demi-monde of Paris who so ignores her husband and children that her sister takes over her domestic duties. Sarony's photograph suggests a similar judgment: through her stoop and upward gaze Bernhardt is made to defer to some greater, higher power – that of the photographic apparatus, or the (male) viewer.

Psychoanalytic theory offers possible explanations as to why this may be so. According to Freud and Lacan, women's lack of a penis (Freud) or phallus (Lacan) causes castration anxiety in men. Men deal with that anxiety by creating a fetish, an over-valued woman; or they can respond sadistically, creating a narrative of control and punishment, to devalue women. Men can create a fetish from some part of a woman's body or some item associated with it, but they can also create it from the body as a whole. For a man, then, looking at a woman evokes both anxiety and the production of a fetish to protect him from this anxiety. With this look (or "gaze") men deny the female body any meaning of its own. Women are thus forced into the role of "other" to the male, which allows for the identity of the latter to be concretized as such. In this way, castration anxiety produces the "otherness" of the stereotype.

Such thinking argues that Bernhardt, presented in character, invites male viewers to project fantasies onto her body. She leans against a prop, as if she had not the power or strength to support her own body. Rather than return the viewer's gaze – an action by which she would lay claim to her own subjectivity – she gazes upward into space.

Colonialism, Race, and the "Other"

The process of describing the body is never innocent. One must always ask who is doing the describing, and why? In the case of the many photographs made in the nineteenth century of the indigenous peoples of countries outside Europe, the answer must very often be Europeans, exerting social control over colonized peoples.

The nineteenth century was a period of massive colonial expansion as Europeans came to exercise dominion over many other lands and peoples. Recent scholarship on the stereotypes formed within colonialism extends feminist and psychoanalytic theory to suggest that just as men are dependent upon women as an "other" against which their own maleness is defined, so white Europeans have used the non-white cultures of Asia, Africa, Australia, and the Americas as a means of defining both their own culture and themselves.

As a tool for literalizing stereotypes and for exercising symbolic control over the bodies of others in the form of their photographic surrogates, photography played a central role in the formation of colonialism. It was not alone in this process ("orientalist" subjects in Romantic painting were also stereotyped).

But unlike such obviously handcrafted images as paintings and prints, photographs belied their status as statements about the world, and seemed instead to be truthful, uninflected restatements of that world. The fact that the power of photographs to control and stereotype was invisible made them especially insidious tools in the establishment and maintenance of colonialism.

This was furthered by their widespread distribution and consumption. Large commercial photography firms were established early in the 1850s, and produced photographs both as postcards and individual prints, as well as in albums intended for the drawing-room tables of Europe. Such photographic albums in particular were used by nineteenth-century Europeans for the fetishistic collecting, controlling, and defining of the bodies of native inhabitants of newly colonized lands.

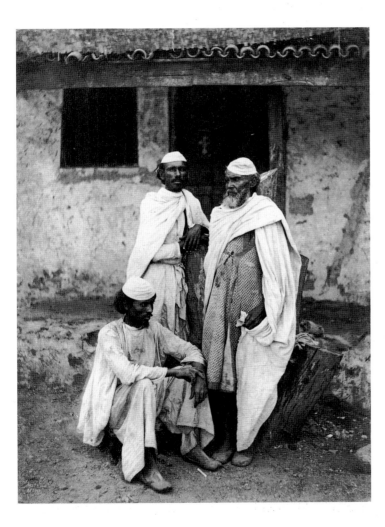

8. FRITH AND COMPANY
(British 1820-1898)
Untitled (Three men in white caps), 1880s. Albumen print, 10³/₄ x 7¹/₂" (24.9 x 18.8 cm). Spencer Museum of Art, University of Kansas.

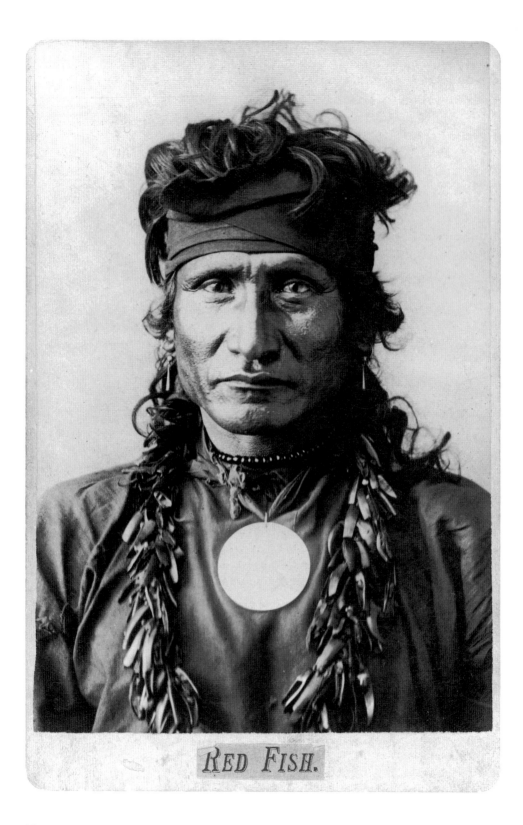

RED FISH.

The Nineteenth Century: Realism and Social Control

An untitled photograph of three men, made in India probably in the 1880s, demonstrates the role photography played in the literal collecting of the whole cultures of foreign lands (FIG. 8). The photographer is unknown, but the photograph was published by Frith and Company of Reigate, England, the largest photographic publishing firm of its time. Its director, Francis Frith, had made his first photographic expedition to the Middle East in 1856, and went on to be one of the most successful of the many photographers whose careers were inseperable from colonialism.

The three men in the photograph seem mute, unable to speak for themselves. They do not return the gaze that addresses them, for that would grant them subjectivity, and plant them on a more equal ground with the photographer and viewer. Instead, the photographer has portrayed them with scientific detachment as specimens, as "the other" to the European viewer. The belief that photographs were true re-creations of the real gave Frith's picture a documentary status, and obscured the role it played within the broader colonial context in producing "otherness." The careful arrangement of the men seems at first to be ordered merely aesthetically, conforming to contemporary pictorial conventions. But posing the heads in three-quarter profile also conformed to current conventions of ethnographic photography, which had the goal of recording specific physiognomic details. The very precision and clarity achieved in this glass-negative print plays a role in the production of "otherness," in that it allows the eye to savor the strangeness of skin tones, facial features, clothing, and housing. Unlike Hill and Adamson's group, whose conviviality is conveyed by their conjoined bodies, these men seem rigid, and cut off from each other. And unlike the intimate relationship between the men and the viewer that Hill and Adamson established through close cropping, Frith's men are distanced from the viewer. They seem less like friends and more like alien specimens, their entire bodies fully in sight and surrounded by a broad space which positions the viewer at a safe, objective distance from them.

In photographs less pictorial than Frith's, the colonized body was perhaps more clearly constituted. Many commercial photographers of the last third of the nineteenth century made seemingly straightforward portraits of exotic types. These pictures were intended primarily as tourist souvenirs but they also served the needs of anthropologists and ethnographers, who used them in their efforts to measure, define, and categorize bodies. In the 1880s David F. Barry, who worked as a professional

9. DAVID F. BARRY (American, active 1880s) *Red Fish*, c. 1885. Albumen-silver print 6^1/$_8$ x 4^1/$_8$" (15.3 x 10.4 cm). Museum of Anthropology, University of Kansas.

photographer in the town of Bismark in the Dakota territory of the northern central United States, produced photographs of Native Americans intended primarily for tourists, who collected them as souvenirs of the American West; but they, too, served the needs of ethnographers and anthropologists. Barry's pictures show Native Americans frontally from mid-chest up, centered within a neutral space (FIG. 9). Although this pose is similar to that of early daguerreotype and tintype portraits, its meaning here is completely different. The subjects of early daguerreotype and tintype portraits freely elected to be photographed for their own ends. The photographer was paid to serve the sitter and produce a service. A very different power relationship is produced in Barry's photographs. Photographed for purposes he himself did not define, Red Fish was subjected to a camera lens in the service of colonialism, racism, and capitalism.

The head-on pose gives Barry's photograph a scientific cast, and suggests an unbridgeable, hierarchical chasm between photographer and his subject. The seemingly vernacular style, in the tradition of earlier daguerreotype and tintype portraits, loses its innocence here as it serves to naturalize and neutralize an unequal power relationship. The plain background removes Red Fish from the context of his daily life, or friends and peers. (Had Red Fish been placed in an elaborate studio setting, or his body been arranged in a more complex way, the mediating power of the outside culture that deprived him of his own subjectivity would have been revealed more visibly.) As it is, he relates only to Barry, and only as an object of the photograph. The emerging discourse of visual anthropology reduces him further to a racial stereotype, defined through anatomical differences that could be seen and measured. Conjoined with other, similar photographs, this portrait does not describe Red Fish, but serves to create the category "Indian."

Unlike the photographs by Frith and Barry, which were appropriated for use in scientific discussions of race only after they were made, photographs from several nineteenth-century projects intentionally presented the bodies of colonial people according to current scientific belief. In Great Britain the President of the Ethnological Society, T. H. Huxley (a distinguished professor of biology and popularizer of Darwinism), was asked in 1869 by the Colonial Office to devise instructions for the "formation of a systematic series of photographs of the various races of men comprehended within the British Empire." The system he conceived called for unclothed subjects to be photographed full- and half-length, frontally and in profile, stand-

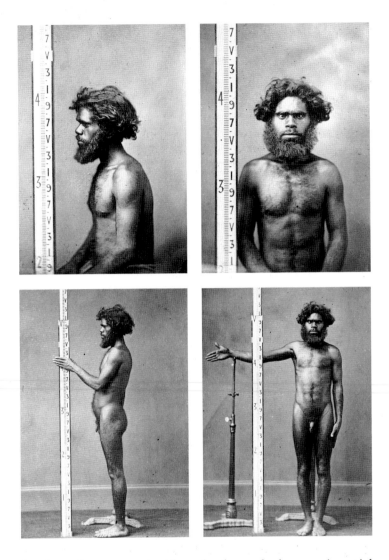

10. PHOTOGRAPHER UNKNOWN
Untitled (Man from South
Australia photographed
according to Huxley's
instructions), c. 1870.
Imperial College Archive,
London.

Thomas Huxley was specific
in what he asked of the
photographers documenting
the "races of men
comprehended within the
British Empire" for the
Colonial Office. His
instructions said that subjects
should stand with ankles
together "in the attitude of
attention." For full-length
frontal views, subjects were
to extend the right arm fully,
palm forward; for full-length
profile views, they were to
bend the left arm upward at
the elbow.

ing in each exposure beside a clearly marked measuring stick
(FIG. 10). Such photographs reproduced the hierarchical struc-
tures of domination and subordination inherent in the institu-
tions of colonialism. The photographs showing fullest compli-
ance with Huxley's method were of subjects over which the
state had absolute control: inmates at the Straits Penal Colony,
prisoners in South Africa, and Aborigines in South Australia.

Other nineteenth-century projects place photographs of the
body at the point of intersection between colonial and scientific
concerns. In 1850 the Harvard University natural scientist Louis
Agassiz commissioned daguerreotypes of black slaves in the
American South to demonstrate what he considered the inherent
inferiority of the black race, but these daguerreotypes serve

instead to document the social system under which they were produced. The bodies in these photographs, robbed of their dignity in being posed nude, replicate the larger loss of freedom suffered through the institution of slavery; they are presented as specimens of a notional "type" rather than as individuals. Racial stereotypes, and "race" itself, were also produced in photographs made for the Berliner Gesellschaft für Anthropologie, Ethnologie und Urgeschichte (the Berlin Society for Anthropology, Ethnology, and Early History) in 1870 by Carl Dammann, who systematically made paired frontal and profile photographs of non-Europeans as part of a project to define racial types.

Like other social scientists of the second half of the nineteenth century, Agassiz and Huxley were positivists, and judged sense perceptions to be the only impartial basis for human knowledge and precise thought. They considered photography similarly: for them it was another way to observe the world without bias. Photographs could serve Agassiz and Huxley as self-evident documents, proving to their satisfaction the existence of fixed racial types, whose distinguishing anatomies also declared differences of personality and character. Today we would say that both absolutes – the "reality" of photography and the "fixity" of racial types – were culturally determined, the one serving to reinforce the other.

The photographs produced by and for Frith, Barry, Agassiz, Huxley, and Dammann define the subjects they depict as "others," whose bodies are the objects of a controlling gaze. But they also define the viewer, giving him or her authority and power. Such images were reminders of the power of Europeans: the power to possess, hold, and view photographs that amounted to a symbolic ownership of the bodies represented in them. They continued the role that the historian C.B. McPherson claims collecting has played since the seventeenth century within Western capitalism – the identification of individualism with the right to own and possess.

Criminology, Psychiatry, and Human Locomotion

Nineteenth-century capitalism also demanded powerful yet inconspicuous means of social control over the white majorities in their own countries. Social scientists in criminology, psychiatry, and other new disciplines helped to define "normal" behavior, and by systematically identifying and punishing "deviant" behavior, often with the help of photographs of the body, they formalized the distinction between the "center" and "margins"

of society, and created hierarchies that valued the former over the latter. Photography had an emerging role, for example, in the system of criminal justice. The industrial cities of the nineteenth century created anonymity: because the forces of law enforcement were now dealing with such large numbers of people they could not know them by sight. A criminal could easily escape the consequences of an earlier offence by using an alias. In the 1870s England instituted a nationwide policy of photographing convicted criminals to fix upon them absolute and unchangeable identities. Similarly in 1871 Thomas John Barnardo employed photographers at his "Home for Destitute Lads" in the East End of London to make a systematic photographic record of children both as they entered and left the home (FIG. 11). Among the purposes Barnardo cited for the photographs was their use to connect children with criminal acts they might have committed before entering the home, and to

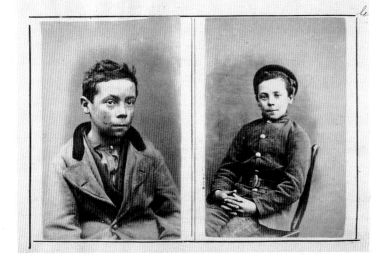

Admitted January 5th, 1876.

Aged 16 Years.

Height, 4-ft. 11-in.

Color of { *Hair, Dark Brown.* *Eyes, Brown.* }

Complexion, Dark.

Marks on body—None.

If Vaccinated—Right Arm.

If ever been in a Reformatory or Industrial School ? No.

11. THOMAS BARNES and RODERICK JOHNSTONE *Personal History of a Child at Dr Barnardo's Home,* 1874-1883. Albumen-silver print on letterpress stock. The Barnardo Film Library, London.

recover those who ran away from it. As with photographs by Frith and Barry, photographic portraits included in the police files and Barnardo's reports on wayward juveniles were far from being a means of social elevation. To be photographed in this context located one among the observed, controlled classes of people. Photography could be used in the service of colonialism and law-enforcement because it was believed to be truthful. The use of the identification photograph asserted that it was an unquestioned statement of identity. From these photographs descend today's police mug shots (introduced in the 1870s, when England instituted a nationwide policy of photographing convicted prisoners and the New York City police began the so-called "Rogues Gallery" – a photographic album of convicted criminals), "wanted posters" (first used in 1865 to search for John Wilkes Booth and his two fellow conspirators in the assassination of Abraham Lincoln), and national identity cards.

Photography of the body played a role also in the sciences of psychiatry and physiognomy (an attempt to use facial features as empirical evidence of human character). In the early 1850s Dr. Hugh Welch Diamond, superintendent of the Surrey County Asylum in England, used photography empirically, as an objective tool of psychiatric diagnosis and treatment, and for the identification of the female inmates under his care. A similar belief in photography's power to provide objective documentation is manifested in the series of photographs made in 1862 by the Frenchman Adrien Tournachon, the brother of the photographer Nadar, to illustrate a book entitled *Mécanisme de la physiognomie humaine*, written by Dr. Guillaume-Benjamin-Armand Duchenne de Boulogne, the founder of electrotherapy. In this book Duchenne extended his electrotherapy research to the study of human character from facial features. One of Tournachon's pictures, *Effroi (Fright)*, shows electrodes applied to the nerves and muscles of the face in order to create the facial expression specific to this emotion (FIG. 12). Tournachon's photographs were also used as illustrations for *On the Expression of the Emotions in Man and Animals* (1872) by Charles Darwin, together with photographs commissioned by Darwin from the Anglo-Swedish photographer Oscar Rejlander. Duchenne, like Darwin, was a positivist, and considered the psyche as something with verifiable, visual aspects. (A few years later Sigmund Freud rejected the privileged status of vision and the visual in Duchenne's notion of psychiatry when he used the verbal interaction of analyst and analysand as the basis of psychoanalysis.)

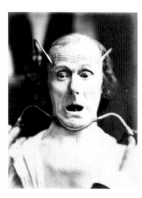

12. GUILLAUME-BENJAMIN-ARMAND DUCHENNE DE BOULOGNE (French, 1806-1875) *Effroi (Fright)*. From *Mécanisme de la physiognomie humaine*, 1862. Albumen-silver print from wet-collodion glass negative, 4³/₄ x 3³/₄" (12.2 x 9.4 cm). The Museum of Modern Art, New York.

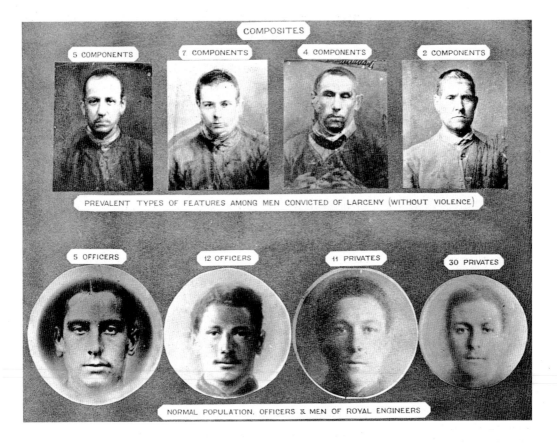

COMPOSITES

5 COMPONENTS | 7 COMPONENTS | 4 COMPONENTS | 2 COMPONENTS

PREVALENT TYPES OF FEATURES AMONG MEN CONVICTED OF LARCENY (WITHOUT VIOLENCE)

5 OFFICERS | 12 OFFICERS | 11 PRIVATES | 30 PRIVATES

NORMAL POPULATION. OFFICERS & MEN OF ROYAL ENGINEERS

Physiognomy and criminology came together in the series of photographs made by the British scientist Francis Galton for his *Inquiries into Human Faculty and its Development* (FIG. 13). Galton, who founded eugenics (the study of human improvement by genetic control), attempted to systematize yet further the study of criminality. He photographed individuals convicted of crimes of violence, and formed combination portraits of them by printing several negatives on top of each other, so that some sort of visual average or type would emerge. Even less benign were Galton's efforts, in 1885, to form by the same photographic means what he called "composite portraits of the Jewish type."

Biological science of the nineteenth century also sought to redefine the body, to arrive at a fixed and circumscribed understanding of it. Questions of realism and control are both central to the work of Eadweard Muybridge and Etienne-Jules Marey. Each man made photographs designed to analyze the movement of the human body. Their works have traditionally been grouped indiscriminately together, but recent scholarship suggests a clear distinction between them.

13. FRANCIS GALTON (British, 1822-1911). Untitled. From *Inquiries into Human Faculty and its Development*, 1883.

Marey's photographs fit within the scientific and medical uses of photography in the nineteenth century. Marey was a French physician who practiced physiology – the study and quantification of the human body. His great achievement was the invention of devices that translated the results of quantitative measurements of the human circulatory and muscular systems into graphic forms that could easily be visually comprehended. His photographs, which were made with various exposures on a single sheet of film, recorded progressive positions of the human body, performing specific actions, over set intervals of time (FIG. 14). They accurately *and visually* recorded movement within time and space.

Muybridge was a photographer of the forests of the Yosemite Mountains of California when he was commissioned in the 1870s by Leland Stanford Jr., former governor of California, railway tycoon, and owner of the Great Palo Alto Breeding Ranch, to use photography to resolve a bet: did the four legs of a galloping horse all leave the ground at any point? Muybridge devised a system using multiple cameras and trip wires to provide a series of sequential photographs of a horse in motion. Stanford won his bet (one leg must always remain in contact with the ground) and Muybridge used his share of the winnings to produce a series of photographs of humans and other creatures for a book entitled *Animal Locomotion* (FIG. 15). These photographs, reproduced in the book in collotype (a process that reproduces photographs in ink with no discernible grain), show how human and other bodies *appear* when they are performing various activities and enacting various narratives. The grids against which the figures move and the grids into which the individual frames are

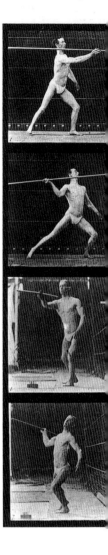

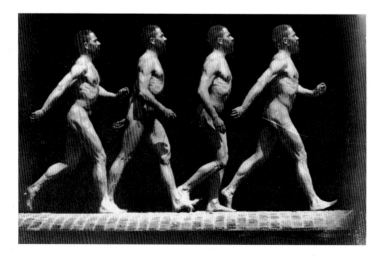

14. ETIENNE-JULES MAREY
(French, 1830-1904)
Walk, 1891. Gelatin-silver chronophotograph.
Collège de France.

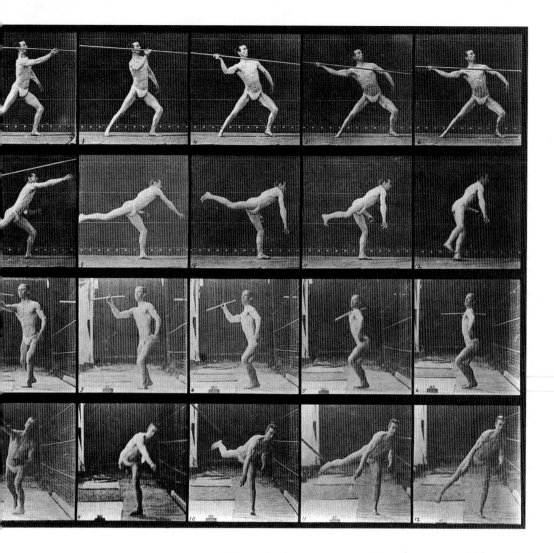

15. EADWEARD MUYBRIDGE (American, b. England, 1830-1904). Untitled. From *Animal Locomotion*, 1887. Collotype, 9¹/₈ x 12¹/₂″ (23.3 x 31.7 cm). Spencer Museum of Art, University of Kansas.

organized suggest a level of scientific certitude that the photographs do not have, primarily because the relationships of time and space from frame to frame are neither obvious nor specified. In contrast to Marey's project, which produced scientific knowledge by sacrificing the representation of a coherent body, Muybridge's project was ultimately artistic, concerned with the representation of the body within visual narratives that symbolize the overarching scientific discourse of the age. In style – not content – Muybridge's photographs reflect the degree to which the sciences of the later nineteenth century did indeed define the body in other photographs.

Death and War

Closely aligned with the use of photography to define the living body within the context of the social and biological sciences was the role that photography came to play in the nineteenth century in defining death. In depicting the dead with all the absoluteness and finality that secular empiricists said was their state, photography restated its claim to absolute truthfulness. With the exception of posthumous portrait photographs of children, which tried to make the subjects look alive (FIG. 16), photographs of the dead were valued as indisputable evidence that a person was indeed deceased. The fascination exerted by photographs of dead bodies echoed the attraction held by death masks (casts made from the faces of prominent persons immediately following their deaths); in each case, evidential power accrued to the image because it seemed produced automatically rather than by hand.

Photographs of corpses were some of the most important images produced when photography made its debut in the reporting of war in the 1850s and 1860s, with the Crimean War and the American Civil War. The technology of photography at this period was too cumbersome for it to be of much use in documenting an actual battle. Cameras had slow shutters and could record only stationary objects clearly. The "wet-plate" negatives then in use had to be exposed before the collodion that bound the silver salts to the glass had dried. Because photographers had to work near darkrooms set up in tents or wagons, which could be easy targets for enemy fire, they chose to work at safe distances from actual battle, producing pictures of bridges and of soldiers in their camps. It was through pictures of the dead left behind that photographers suggested the battles that had taken place.

In time government censors came to prohibit the distribution of wartime photographs showing a nation's own dead, but during the Civil War and the Crimean War photography was still so new that administrators did not yet understand its power to produce emotionally disturbing and politically potent pictures. The gruesome reality of the battlefield was brought home to civilian populations for the first time through stereographic cards and photographic albums. Dead bodies and photography combined to assert the horror of war. During the Civil War, Alexander Gardner and his employee, Timothy O'Sullivan, were the first to photograph battlefields before the casualties of the struggle had been removed or buried, producing works such

16. PHOTOGRAPHER UNKNOWN
Untitled (Dead child),
c. 1850. Daguerreotype. International Museum of Photography, George Eastman House, New York.

Early portrait photographs had to be done by professionals in their studios, and were relatively expensive. Many children died without having been photographed during the period of high infant mortality that coincided with the invention of photography. In order to have visual records of dead children, parents paid photographers to photograph their bodies in their homes; sometimes parents went so far as to carry their child's body to a photographer's studio for a post-mortem portrait.

as O'Sullivan's *A Harvest of Death, Gettysburg, July, 1863* (FIG. 17). The emotional impact of such pictures was in large part due to the incontestable proof they seemed to offer of the carnage of battle; however, recent research has shown that Gardner altered the positions of the bodies he photographed if he felt that a set-up scene would be more powerful.

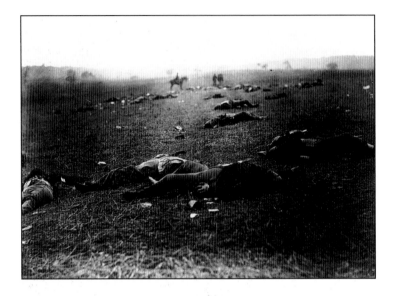

17. TIMOTHY O'SULLIVAN (American, 1840-1882) *A Harvest of Death, Gettysburg, July, 1863.* From *Gardner's Photographic Sketchbook of the War,* 1866. Albumen-silver print.

Death appears again in a photograph of a hanging in the American West (FIG. 18). Like many nineteenth-century photographs, this picture seems simple, almost natural; yet within its historical and cultural context it is full of meaning, and summarizes many of the issues raised by nineteenth-century photographs of the body. The photograph seems intended to offer incontrovertible proof of a death having occurred, but it is only in the context of the construction of photography as a realist medium that this intention is fulfilled. Perhaps less intentionally, the picture gains meaning within the context of social control, depicting one of its extreme practices: it shows the body of a man, William Biggerstaff, who was convicted of killing an opponent in an argument and was hanged on the morning of 6 April 1896. The picture is also defined in the context of race and racism. Biggerstaff's black body is seen between those of two live white men. The photograph proposes an absolute difference between their bodies and Biggerstaff's, suggesting that their racial differences are as profound as the difference between life and death. This discourse of race is printed on Biggerstaff's body. He is a black former slave, judged and executed within a

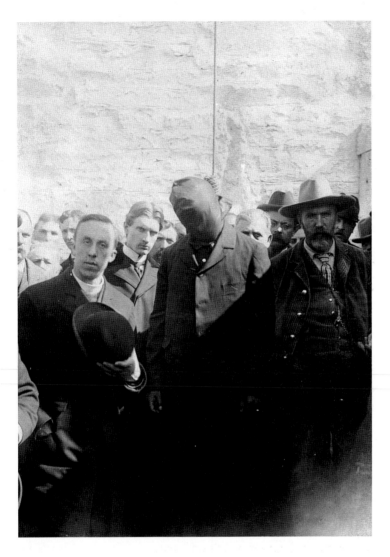

18. James Presley Ball
(American, 1825-1905)
*The Hanging of William
Biggerstaff,* 1896.
Photograph Archives,
Montana Historical Society.

justice system established and administered by white Americans.
Finally, the context of race affects as well the relation of the pic-
turemaker to the original event, for the picture was made by
James Presley Ball, a free black man, whose photographs made
in the western United States during the years after the Civil War
recorded the lives of other black Americans.

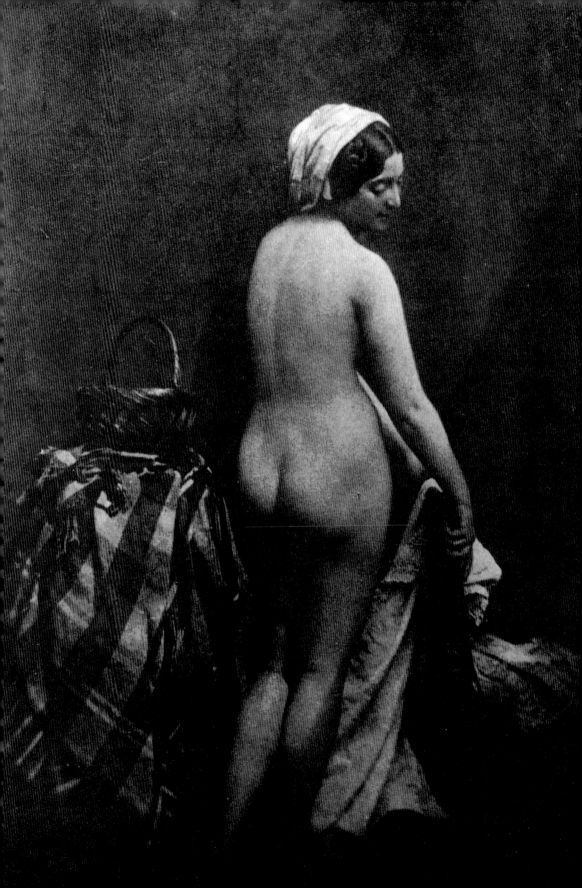

TWO

1850-1918: Gender and Eroticism in Pictorialist Photography

19. JULIEN VALLOU DE
VILLENEUVE
(French, 1795-1866)
Study after Nature, c. 1851.
Salted-paper print from
calotype negative, 7 x 5″
(17.6 x 13 cm). Cincinnati
Art Museum.

Photographs made as documents, whether scientific or otherwise positivist, are nevertheless dependent upon conventions of style, as we have seen. Photographs made as art are equally subject to ideological forces.

During the second half of the nineteenth century, in addition to its use as a means of defining the human body in terms of class and of normative behavior, photography also came to be used to create the gendered and erotic body. This development took place largely in photographs that were created with an artistic, rather than a documentary, intent. Conventional thinking suggests that the difference between these categories lies in the absence or presence of style: photographs made as documents are realistic, transparent, and innocent of style; those made with an explicit intention to be art have style, which is tantamount to saying that they are somehow less truthful, less realistic, less factually accurate. They derive their meaning less from their accurate transcription of factual reality than from their expressive, suggestive powers.

Artistic Nudes and Pornography

In the early 1850s, a number of photographers, especially in France, including Eugène Durieu, Auguste Belloc, Félix-Jacques-Antoine Moulin, and Julien Vallou de Villeneuve, produced pictures that presented the female body as an aesthetic and erotic object (FIG. 19). Many of these photographers had first been painters or printmakers. Their photographs, made ostensibly as studies to be used by their fellow artists, were part of a shift in French culture. Beginning with the French Revolution, and continuing into the period of the first Empire (1804-1815), the male body dominated figurative art. The Neoclassical art of Jacques-Louis David and Jean-Auguste-Dominique Ingres made great use of sharply defined, muscular male nudes in their paintings of subjects from classical antiquity. However, following the annual exhibitions of paintings at the unjuried Paris Salons of the Second Republic (1848-1852), and continuing into the period of the Second Empire (1852-1870), French artists (Gustave Courbet in particular) shifted the erotic focus from the male to the female body, one that was ample, full, maternal – and antithetical to the taut male body of Neoclassicism. Courbet is known to have painted from photographic nude studies by Vallou de Villeneuve, and he probably used one of them as the model for the standing nude at the center of his allegorical painting, *The Artist's Studio* (1855). Courbet's paintings take from Vallou's photographs less the sharp linearity that outlines the figures than their bulk and physical presence.

Photographic studies made for painters also served as a form of soft-core pornography, purchased by non-artists and used as objects of voyeurism. The twinned purpose – combining art and eroticism, or even hiding eroticism within art – was typical of Second Empire art. Photographs of nudes functioned much like the large Salon paintings of such established artists as Alexandre Cabanel and William-Adolphe Bouguereau, which under the guise of art made unclothed female bodies accessible to male viewers for their sexual fantasies. Photography and the increase during the nineteenth century in visual pornography are dual products of the mass culture born at the same time. For the elite of previous centuries, the medium for pornography had generally been the written word. It was only with the extension of the market to meet the needs of men who had the means to buy pornography, but were not leisured or educated enough to be at ease with it in a literary form, that there came to be an increase in pornography that was visual.

GUSTAVE COURBET
The Artist's Studio, 1855 (detail). Oil on canvas, 11'8" x 19'3" (3.6 x 5.9 m) Musée d'Orsay, Paris.

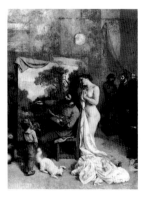

The specific role of photography in the production of visual pornography (especially sexually explicit pornography) is inseparable from the arguments about documentation and truthfulness that surrounded nineteenth-century photography. The same conventions that produced photographs as evidence of reality were at work here; pornographic photographs did not satisfy through narrative richness, as had written texts, but by their apparent truthfulness.

In England, the body in art and photography was also largely female, but was more often clothed. It has been argued that the way women are depicted in art of the Victorian period is inseparable from social and political issues arising from, among many other things, the crisis of control in colonial India after the Indian Mutiny of 1857. The manufacturing and merchant classes sought to establish cultural dominance by asserting middle-class notions of sexual and reproductive respectability over society as a whole. The attempt to regulate prostitution, birth control, and health care placed the female body at the center of this struggle.

Part of the establishment of this class hegemony were the collective efforts of various occupations to redefine themselves as professions, and in this too use was made of the female body. Medical doctors successfully established their monopolistic status as the only professionals suited to provide health care through a series of practices that defined the female body as being vulnerable to sickness and needing the constant supervision of experts.

This effort to use medicine to control women's bodies is suggested in *Fading Away* (FIG. 20). This toned albumen-silver print from five negatives, made by the British photographer Henry Peach Robinson, shows two women tending a sick girl, while a man (her father? her doctor?) turns away and looks out the window. The effort to medicalize and control women's bodies is first represented in the ostensible narrative: male doctor cares for female patient. This effort is twice restated symbolically in the making of the picture: first, in the directorial control the photographer has over the body of the model for the sick girl, and second, in the technical control the photographer has over the finished print through his use of combination printing, a method of making a photographic print from multiple negatives, allowing each figure to be posed and lit independently. Just as in medicine, doctors subject bodies to control, so here, within the tradition of realism, the artist controls the characters. The female body is redefined and reordered, both scientifically and pictorially, by forces and powers external to itself. It is not

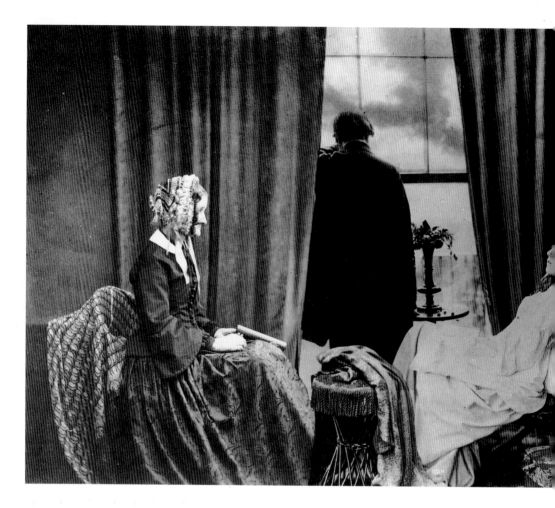

the signifier of itself or the woman's own subjectivity, but of something else.

The Body and the Sexuality of Children and Adolescents

The ideology of Victorian England also controlled the display of bodies in the work of a woman photographer, Julia Margaret Cameron. An amateur only in the sense that her social and financial position did not oblige her to live from her work, Cameron took up photography in 1863 as a diversion and soon adopted it as a passion. In addition to making soft-focus portraits of the talented and powerful critics, artists, and writers she counted among her friends, she also photographed friends and family members in costume, acting roles she had assigned to them. *Venus Chiding Cupid and Removing His Wings* (FIG. 21)

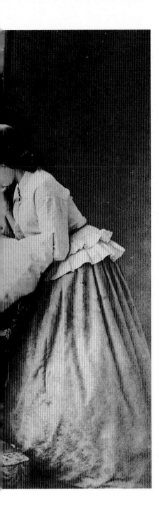

21. JULIA MARGARET CAMERON
(British, 1815-1879)
*Venus Chiding Cupid and
Removing His Wings*, 1872.
Albumen-silver print from wet-
collodion glass negative. Royal
Photographic Society, Bath.

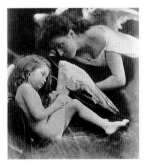

mythologized the Victorian cult of domesticity. Victorian ideol-
ogy created as the realm of women's activity a home that was
distant and separate from the urban center, which was a realm of
male activity seen as unsafe and unhealthy for women. The cult
of domesticity coincided with the professionalization of health
care; both constructed women's bodies as vulnerable and need-
ing protection and refuge. Within Cameron's allegorical depic-
tion of the victory of sacred over profane love is contained
another, more hidden, allegory: that of domestic virtue, which
assigned to women in Victorian England limited roles at home,
away from the realms of business and politics.

In this photograph the body most exposed, most unclothed,
is that of a child. The allegory of Venus and Cupid excuses its
presence, yet the depiction of a naked child in the deeper alle-
gory of domesticity seems to be disturbing. The very silence of
the Victorian middle class on the subject of sexuality has been
seen as the result of what was, in fact, a fierce concentration
upon this very issue. The more it was disavowed, the greater the
presence of sexuality as the central feature of bourgeois life. In
the same way childhood sexuality, disavowed by the masquerade
of *Venus and Cupid*, retains in the image the uneasy presence of
the sexualized child.

A less heavily symbolic representation, but one that still
defines the female body within Victorian domestic space,
appears in the photography of Clementina, Lady Hawarden.
Like Cameron, Lady Hawarden drew her photographic subjects
from her own family. In photographs made in the 1860s, she
most frequently photographed her daughters, singly and in
pairs, in domestic spaces, often before mirrors, with diffused
light pouring in through large windows (FIG. 22). The light,
mirrors, and windows make the interior space recognizably
domestic, with a sensuality that the cult of domesticity called
feminine. Mirrors not only restate the process of photography;
they also have a psychosexual power of their own. Posed before
reflected images of themselves, Hawarden's daughters seem
caught in a sensual self-absorption, at odds with the sexual
restraint encouraged by Victorian society. The reflected images
also suggest the role played in sexual fulfillment by vision and
visuality, points at which photography and the body intersect.

Victorian notions of gender and sexuality concentrated on
images of the bodies of young children, particularly in pho-
tographs by Cameron's contemporary, Charles Lutwidge Dodg-
son, who under the pseudonym Lewis Carroll wrote the chil-
dren's book *Alice in Wonderland*. Carroll photographed

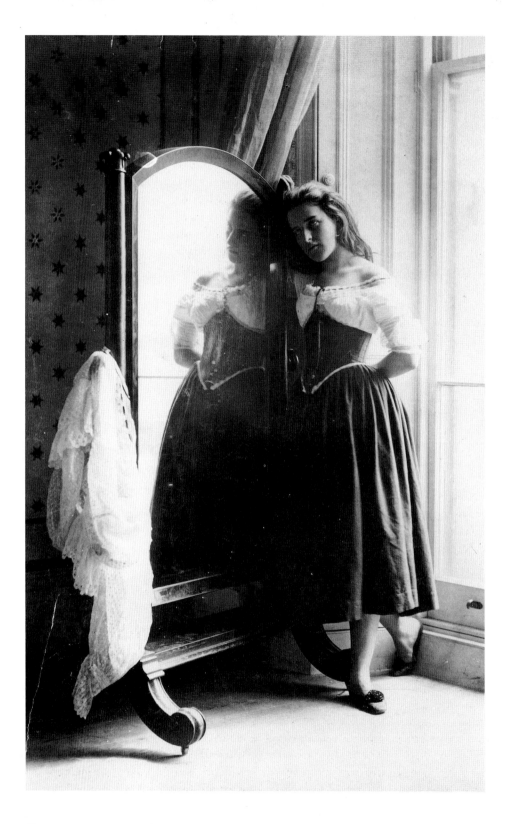

pre-pubescent girls at a time when the legal definition of child-hood in England was under debate, as laws defining the age of consent were being rewritten. (In 1861 sexual intercourse with a child under 10 was a felony and under 12 a misdemeanor; in 1875 the age of consent was raised to 13, and in 1885 to 16.) These laws evolved in the context of a public outcry at child prostitu-tion and the spread of venereal diseases, but they also had the effect of giving legal standing to the Victorian notion of child-hood as an extended period of sexual latency. Carroll was very careful to get consent from parents and the girls themselves to make his photographs, and while the photographs may have been produced out of Carroll's own fear of the sexuality of adult women, they serve to give visual form to a specific ideology: that children do have a sexual nature even at a time when laws and society argue they should not (FIG. 23).

The ambiguous sexuality of adolescent bodies is also found in the works of the American Pictorialist photographer Alice Boughton. In her *Children – Nude* (FIG. 24), a group of four chil-dren are huddled closely together, their bodies touching one another. Their eyes are downcast and unable to return the gaze of the viewer. Lighting and the figures' arrangement reveals the contours of their bodies, emphasizing the curves of their but-tocks, shoulders, chests, and abdomens. These curves and the constant touching of figure to figure projects onto these children just the kind of sexual consciousness that society denied they possessed.

The aesthetic under which Boughton and other Pictorialists worked constantly sought ways to visualize the invisible and the unnameable. In giving visual form to the repressed sexuality of pre-pubescent and barely pubescent children, Boughton found a subject for her art. As with the works of Charles Dodgson, this photograph claims for these children an innocence which has meaning only in the face of its opposite possibility.

An aesthetic discourse on women's and children's bodies continued in the photographic work of other Pictorialists. The central role of the female nude in photography undertaken as an aesthetic activity appears in the series of female nudes made in the late 1890s as a collaborative effort by the two leading Amer-ican Pictorialists, Alfred Stieglitz and Clarence White. This col-laboration was remarkable for the nineteenth century, when the romantic cult of genius and individualism had made shared responsibility for the production of art seem out of place. White and Stieglitz make us wonder, how do photographers work col-laboratively? How would they share the work? How could they

22. CLEMENTINA, LADY HAWARDEN (British, 1822-1865) *Young Girl with Mirror Reflection*, c. 1863-1864. Albumen-silver print from wet-collodion glass negative. Victoria and Albert Museum, London.

23. CHARLES L. DODGSON (Lewis Carroll; British, 1832-1898) *Beatrice Hatch*, 1873. Albumen-silver print with applied color. Rosenbach Museum and Art Library, Philadelphia.

jointly have a "vision" or "style"? This rare act of collaboration involved two men photographing one (nude) female, an activity all the more provocative because photographing a nude woman was frequently held to be analogous (and sometimes preparatory) to having sex with the woman.

In photographs that he made by himself, Clarence White created a domestic world that would have been identified by contemporaries as highly feminine. The subjects of these photographs are, indeed, often women, seen singly or in groups, and children. As a leader of the Pictorialist movement, which sought

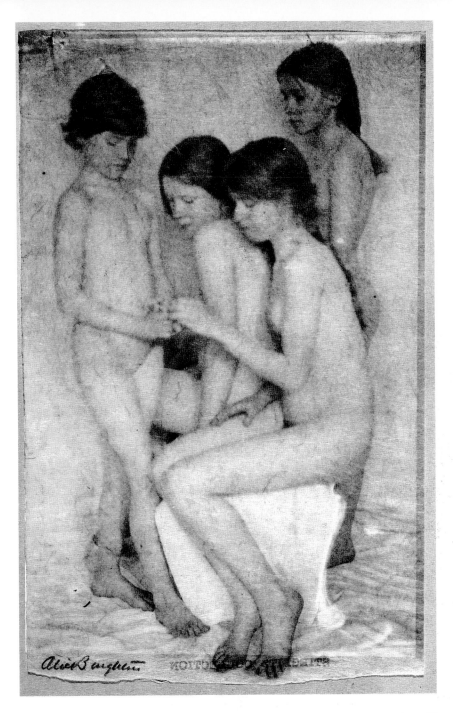

24. ALICE BOUGHTON (American, 1866-1943) *Children – Nude*, 1902. Platinum print, 7⁷/₈ x 4⁷/₈″ (18 x 12.3 cm). Metropolitan Museum of Art, New York, Alfred Stieglitz Collection.

Boughton's arrangement of these children's figures invites the viewer to project adult notions of sexuality onto them. Trying to determine the gender of the sexually ambiguous figure on the left engages the viewer directly in the social construction of adolescent sexuality.

to achieve for photography recognition as high art, White was a colleague and supporter of its many women members; as a teacher, he trained some of the leading women in American photography of the early twentieth century, notably Margaret Bourke-White, the photojournalist of *Life* magazine. Nevertheless, his photographs define women as passive objects of the male gaze, used for the purposes of art and aestheticism. Only a few of the photographs that White made on his own contain the charged sexuality of those he made with Stieglitz. In one a nude young woman clasps her hair behind her head with both hands, suggestively arching her back and pointing her breasts forward. But for the most part White was a typical late Victorian, who equated the creation of private, domestic worlds with the production of art. His *Morning* (FIG. 25), which appeared as a platinotype (a high-quality ink reproduction) in Stieglitz's luxuriously produced journal "Camera Work" in 1908, shows a clothed woman (in this way closer to Victorian England than to Second-Empire France), holding a glass orb and looking far off into the distance. The distant view gives the figure an otherworldliness, but, again, prevents her from returning the male gaze and, in so doing, once more denies the model her own subjectivity.

Women as Photographers, Women as Subjects

At the turn of the century, many women followed Hawarden and Cameron to become Pictorialist photographers. Among them was Gertrude Käsebier. Käsebier studied painting in New York and Paris, then returned to New York to open a photography studio. Her photographs are thoroughly Victorian, showing women in interior spaces, as brides and as mothers, but never with men. They construct separate spaces for women and men, placing women exclusively in domestic spaces, shared only with children and other women. Her photographs present women in very physical ways, yet always as having procreative, maternal, and nurturing bodies that are neither the subjects nor the objects of heterosexual sensuality.

Käsebier shares with Cameron a soft-focus style, intended to make their photographs look like paintings and hence be recognized as "art" and, like Cameron, takes her themes from the domestic world of women and children (FIG. 26). Nonetheless, Käsebier's photographs, produced at the time of the first development of modern feminism, from 1890 to 1920, suggest a subtle tempering of the power over women's bodies asserted by the

25. CLARENCE WHITE
(American, 1871-1925)
Morning. Platinotype, 11¼ x 8⅛" (29.9 x 21 cm). From *Camera Work*, no. 23, July, 1908. Spencer Museum of Art, University of Kansas.

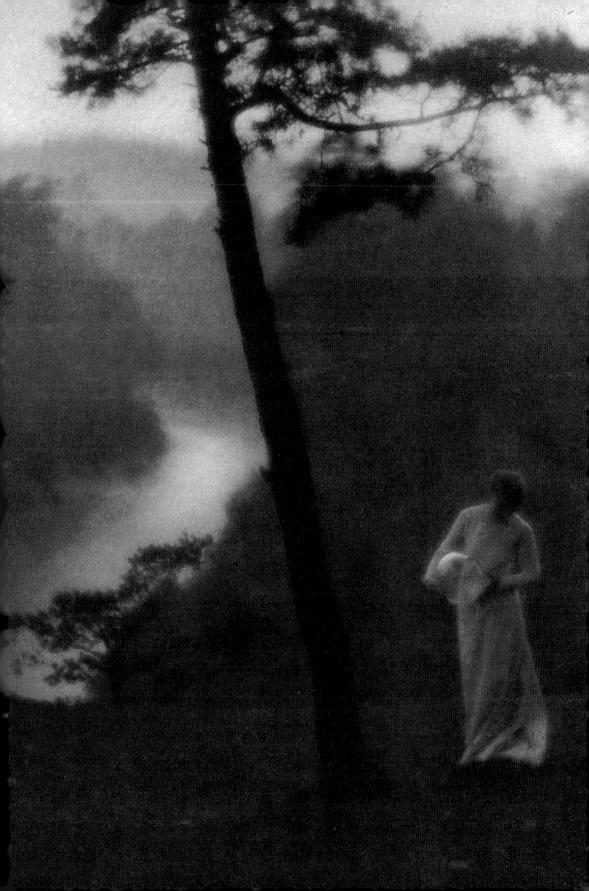

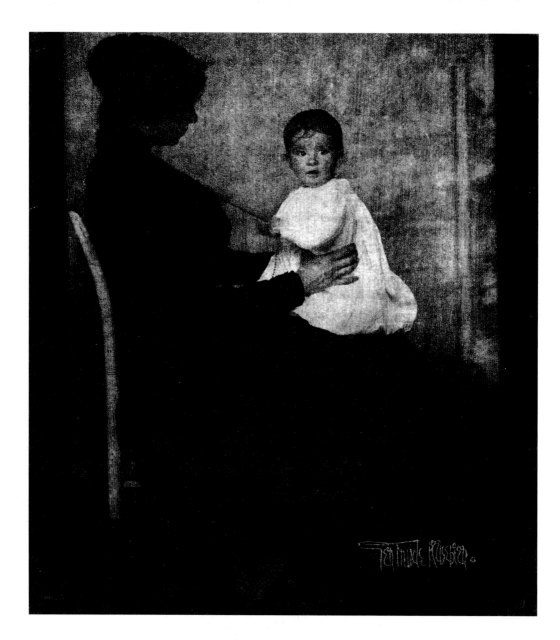

26. GERTRUDE KÄSEBIER
(American, 1852-1934) *Mother and Child (Mrs. Ward and Baby)*, c. 1903.
Gumbichromate print. Library of Congress, Washington, D.C.

Victorian cult of domesticity. Unlike the figures in Cameron's *Venus Chiding Cupid and Removing His Wings*, where physical proximity of bodies suggests close, protective links between mother and child, Käsebier's mothers offer their offspring not only protection but independence.

The feminized, aestheticized domestic world of the Victorian era produced by Cameron and Hawarden, and tempered by Käsebier, was completely inverted by Annie W. Brigman. A self-proclaimed free spirit who spurned social conventions, Brigman chose to use her own body as the subject of a series of photographs she made in the decade after 1903. Her photographs offered a sense of physical freedom for the female body, one connected with the reform movement in women's clothing, which set aside tight dresses and rib-bruising corsets for loose, flowing gowns worn with a minimum of undergarments. She also photographed the female body in wild, uncultivated landscapes (FIG. 27). This move away from the airless Victorian interiors of Cameron and Hawarden reflected a belief that exterior space was more "natural," defined by women rather than men, and more uniquely female. Today, such an invocation of nature is suspected of creating a spurious link between female identity and the generative, reproductive powers of the female body.

By presenting female and children's bodies as aesthetic objects all these photographs reproduce unquestioned the cultural ideology of their time. Another group of photographs deals with the body in ways that question or undermine the dominant ideology of the time, and that represent points of view external or even opposite to it.

Frances Benjamin Johnston, a professional woman photographer, knew Käsebier and like her participated in the Progressive Reform politics that defined many women around 1900 as feminists. Johnston also took a number of photographs at schools that educated Native and black Americans (FIG. 3). These pictures were set up for her large-format view camera. Posing the subject allows the photograph to be worked out in advance, giving the photographer the kind of control over the final image that Robinson sought in *Fading Away* and that traditionally is associated with a painter or draftsman. But posing for a photograph often also renders the body awkward and stiff. This awkwardness is especially intrusive in photographs such as those Johnston made at the Hampton Institute, the federally financed school for the children of former slaves. In these pictures, Johnston shows students at their work around the school, but the very achievements that she hopes to illustrate are made limp and

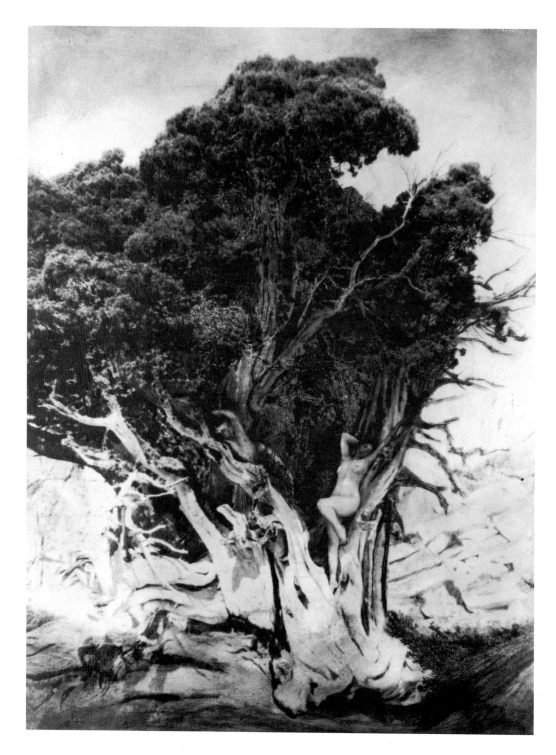

27. Annie W. Brigman (American, 1869-1950)
The Hamadryads, n.d. 9⁵/₈ x 7¹/₈″ (24.5 x 18 cm). The Oakland Museum, California.

1850-1918: Gender and Eroticism in Pictorialist Photography

substanceless by the posing. In this respect, her photographs reproduced the contradictions of liberal reform. The power she has to make these pictures and to have the subjects pose for them was itself a demonstration of inequality, similar to that manifested in nineteenth-century photographs of colonized peoples.

A print entitled *Kansas Delegation to the Michigan Prohibition Meeting* (FIG. 28), made by an unknown photographer in 1918, shows a line of seven women holding signs, which identify the group and extol the benefits of temperance: contentment, prosperity, and happiness. Just as the photographs of Robinson and Cameron helped to reinforce the values of the dominant classes in Victorian England, so this photograph shows these women advocating the values of their class. They do not display themselves nude or as erotic objects; nevertheless, their bodies carry much of the meaning of the image, functioning as symbols of the domestic values of a certain class. They are well dressed and coiffed; and it is clear that they are not working- class or farm-women. They function collectively as an allegory, representing values too exalted and abstract to have otherwise any visible form. The status these sign-carrying women have as bearers of meaning is restated formally in the visual support they give to the colonnade architrave behind them, as if they were caryatids, the supporting columns sculpted in the form of women in classical architecture.

A very different group is assembled in a photograph by the Midwestern photographer Joseph Pennell. In his *Madam Sperber Group* (FIG. 29), six black and mulatto prostitutes are gathered in a semicircle around the woman who runs the brothel where they work. These women, too, do not show their flesh, nor engage the viewer by overtly erotic means. But to the extent that the photograph seems to rob them of their subjectivity, of their life and liveliness, their souls and psyches, they are reduced to their bodies. They are the viewer's "other": women, blacks, whores. Pennell has photographed from higher than eyelevel (note the expanse and angle of the flooring), creating the kind of physical and psychological distance from his subjects that Frith took from his (see Chapter One). These women are neither friends nor peers of the photographer, but specimens under examination.

Several superficial formal similarities connect the two photographs (for example, each has a central figure flanked by two sets of three other figures), but a great difference between them is that all the members of the Kansas delegation return the gaze of the viewer, while only one of Madam Sperber's group does so. What are we to make of this? The members of the Kansas

28. PHOTOGRAPHER UNKNOWN
*Kansas Delegation to the
Michigan Prohibition
Meeting,* c. 1918. Gelatin-
silver print, 8⅛ x 10″ (20.7 x
25.4 cm). Kansas Collection,
University of Kansas.

delegation are clearly on display, but as allegorical figures they participate actively in the creation of the photograph's meaning. The success of the photograph as allegory depends precisely upon the connection these figures make with the viewer. Rather than existing in the photograph only to be looked at, they seize the power to project meaning; and they hold in their hands (literally) the means to construct both their own subjectivity and the reason for the photograph. Madam Sperber and the women with her avert their eyes from the viewer; to meet the viewer's

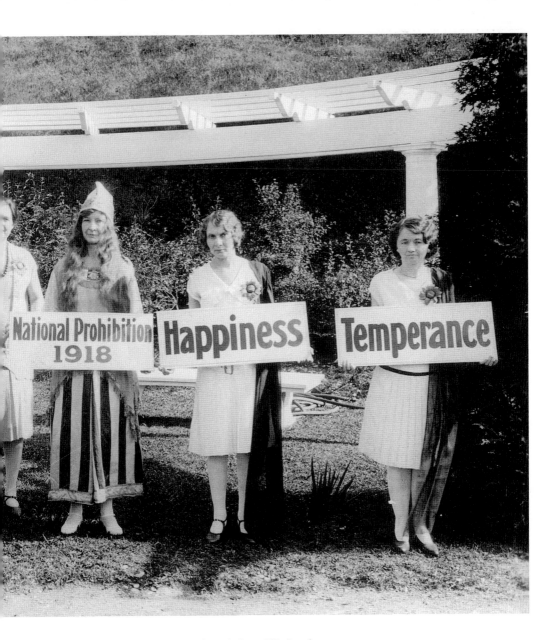

gaze would be to assert their subjectivity. All the figures seem sullen, passive, even Madam Sperber, who was well enough known to be identified by name. Does the difference in race between the two groups of women explain the difference between this photograph and the one of the delegation? Unlike the women in the delegation, who may have welcomed the photographer who assisted in their representation, the women at Madam Sperber's house may well have resented the power over them that accrued to Pennell as a white photographer.

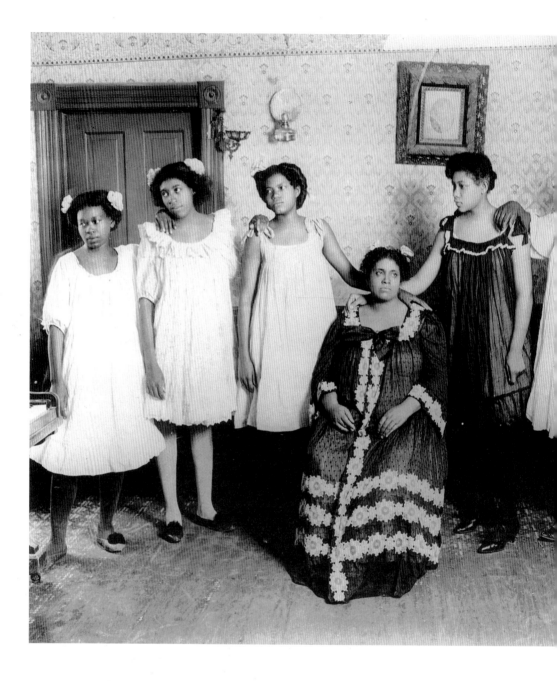

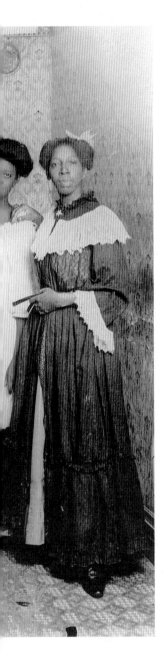

29. Joseph J. Pennell
(American, 1866-1922) *Madam Sperber Group*, 1906. Gelatin-silver print,
8¼ x 10″ (20.8 x 25.4 cm). Kansas Collection, University of Kansas.

30. E. J. Bellocq
(American, 1873-1949) Untitled (Seated Woman in Tights with Hands Behind
Head), c. 1912. Gold chloride toning on printing-out paper, print by Lee
Friedlander, c. 1970, 8 x 10″ (20.2 x 25.2 cm). Spencer Museum of Art,
University of Kansas.

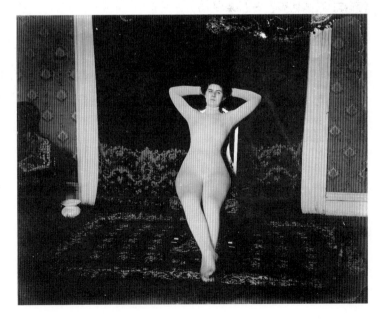

The bodies of prostitutes are also depicted in the photographs by E. J. Bellocq, made in around 1912 in the Storyville district of New Orleans in Louisiana. Bellocq's view of these bodies is different from Pennell's. Bellocq's women engage the camera with a self-possession more like that of the Kansas temperance group than the women at Madam Sperber's. One of his pictures (FIG. 30) shows a woman dressed entirely in a white bodystocking; only her equally white face and dark hair are exposed. White against dark, the stocking emphasizes her hourglass figure; even more, it emphasizes her body while concealing its secrets. Exposed and yet not, the woman assumes a self-confident pose and boldly returns the viewer's gaze.

Little is known about Bellocq, but he lived in New Orleans's red-light district and it seems he knew these women as friends, making their pictures not as salacious pornography but as presents for them. Certainly his photographs, in comparison with those of the other two photographers, present the most powerful images of women.

A woman's control over her body and its presentation is depicted even more strikingly in a series of photographs made at the end of the nineteenth century by the photographer Alice Austin, who lived on Staten Island in the city of New York. Scorning the romanticism of Pictorialists such as Boughton and White, Austin turned to a highly realistic style to give her lesbianism visibility. This style was also useful when she made the illustrations for *Bicycling for Ladies* (1896), a book written by her friend Violet Ward, who had designed the drop-bar bicycle (accommodating female clothing and anatomy, the drop-bar bicycle contributed to women's emancipation as a means of mobility and a symbol of freedom).

In Austin's *Julia Martin, Julia Bredt, and Self Dressed Up as Men, 4:40 p.m., Thursday, October 15th, 1891* (FIG. 31), the three women wear pants, vests, jackets, hats, and painted-on moustaches. Like the Kansas temperance delegation, Austin and her friends actively control their own presentation. The members of the delegation define themselves by holding literal signs; Austin's figures manipulate the semiotics of a cultural sign, clothing. But unlike the delegates, who are allowed to project themselves only within the accepted arena, for women of their class and education, of good deeds and social reform, Austin and her friends dress against the grain. "Maybe we look better as men," Austin commented.

Another transformation of the female body occurs in a photograph by Louise Deshong-Woodbridge, *Self-Portrait as Miner*

31. ALICE AUSTIN
(American, 1866-1952). *Julia Martin, Julia Bredt, and Self Dressed Up as Men, 4:40 p.m., Thursday, October 15th, 1891.* Staten Island Historical Society, New York.

Alice Austin (center) and her friends gain from male dress the easy, self-confident swagger of men. Their attitude towards men's clothing may be like that of the contemporary pop singer k. d. lang, who started wearing men's clothes, she says, not to "come off like a man," but because "there were not other kinds of clothes that had to do with confidence and authority instead of vulnerability and stereotypical sexiness."

32. Louise Deshong-
Woodbridge
(American, active 1880s-1910s).
Self-Portrait as Miner, c. 1910.
Collage from gelatin-silver
prints. Janet Lehr Gallery,
New York.

(FIG. 32). Working in collage, cutting one image and pasting it together with others, Deshong-Woodbridge redefines herself and her body in terms of the work that she as a woman can do. The image is full of unreality and fantasy. The rock wall that suggests her occupation is drawn instead of being real. Moreover, the cut-and-paste work is obvious rather than covert. All this leads the viewer to treat the image in a way similar to Austin's, as a kind of commentary on and parody of certain other contemporary images of women. Just as Austin herself sports the handle of an umbrella sprouting from between her legs, which her smile suggests is done in parody and not envy, Deshong-Woodbridge wears an unlit miner's candle at a spot that suggests reading it simultaneously as a phallic form and the absence of passion.

The Exception: The Male Body

After the mid-nineteenth century, the male body was seldom seen in art aimed at a general (for which read "heterosexualized") public. However, there were exceptions. Joseph Pennell's *Reynolds, 19th Battery, Fort Riley, Kansas* (FIG. 33) presents an unclothed male body; but Pennell's presumed intention, to show the birds tattooed on the soldier's chest, would have required it to be bare. The tattoo is the primary subject of the photograph, to which Reynolds's bare flesh is only incidental. Ironically, while the tattoo may have fetishized Reynolds's body, Pennell did not. Vallou de Villeneuve, Cameron, Carroll, and Boughton reveal flesh only to transform it into nudity and eroticism; Pennell, on the other hand, seems to have a real, tactile, material interest in the bare flesh itself as part of the subjectivity of the sitter. This equal partnership between photographer and subject continues with Reynolds's gaze. Bold as Bellocq's prostitute is,

33. JOSEPH J. PENNELL (American, 1866-1922) *Reynolds, 19th Battery, Fort Riley, Kansas*, 1905. Gelatin-silver print, 7³/₈ x 5" (18.8 x 12.5 cm). Kansas Collection, University of Kansas.

Pennell's subject looks at the viewer still more boldly, having no fear of the controlling gaze of the camera or viewer. Male, white, Euro-American, soldier and free, he has no reason to fear the eye that views him as an eye of power. The straightforward frontality of this photograph is similar to David Barry's portrait of Red Fish (FIG. 9), but differences in intention change the power relationships in the two pictures. Red Fish himself is the subject of Barry's photograph, as the pasted-on label makes perfectly clear. It is he who is looked at. Reynolds is not the subject of Pennell's photograph; rather, the subject is the tattoo. Reynolds participates actively with Pennell in its representation (just as the delegation to the temperence meeting are active creators of the picture that shows them).

A nude male body is intentionally depicted in *Thomas Eakins at 45 to 50* (FIG. 34). Eakins made this picture with the help of an aide and in conjunction with his painting *The Swimming Hole* (1883). The photograph is unusual on a number of accounts. First, it presents a male nude in defiance of the convention that male bodies should not be the subject of art aimed at a heterosexual audience. Second, it presents a body that is old and fleshy, without the taut skin, hard muscles, and firm contours of the young. Third, the body seems feminine. The exceptional nature of Eakins's photograph may be due to his talent as a painter and his willingness to serve as his own model, and in posing himself, he anticipated photography of the 1980s by Cindy Sherman and John Coplans, who refuse to subject anyone's body other than their own to the camera. Eakins's photograph must also be seen in terms of the motion-study photographs he made during the 1880s, using the devices invented by Marey.

34. PHOTOGRAPHER UNKNOWN *Thomas Eakins at 45 to 50,* c. 1884-1889. Platinum print on paper, 3¹/₂ x 4⁷/₈" (8.7 x 12.2 cm). Hirshhorn Museum and Sculpture Garden Archives, Smithsonian Institution, Washington, D.C.

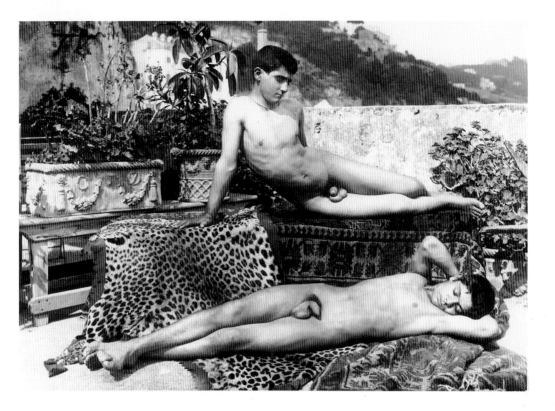

There are also exceptions to the work of photographers such as Boughton, who created images of children that were intended to be chaste, yet which positioned the children's bodies as objects of beauty within the simultaneous expression and repression of their sexuality. Baron Wilhelm von Gloeden photographed Sicilian boys who were older and more sexually mature than the children in Boughton's *Children – Nude*. They are conscious and proud of their bodies, and seem to use them to taunt the viewer (FIG. 35). Boughton's photograph seems cramped, with enough space for the four children only if they push close to one another, touch one another, perhaps even hide or protect their bodies behind one another. Von Gloeden's photograph, by comparison, is spacious; the boys are spread out across it, individually accessible, visually and potentially, for sexual predation.

F. Holland Day also photographed post-pubescent boys. Like White and Boughton, Day was a Pictorialist and used soft-focus and middle tones to give an aesthetic, mystical mood to his photographs. In some of them he presents young boys as erotically desirable, though the homoerotic content is somewhat hidden or subsumed by visual references to Pan or other classical figures. In a notable series of photographs, Day used his own body to enact

35. WILHELM VON GLOEDEN (German, 1856-1931) *Nude Sicilian Youths*, c. 1885. Gelatin-silver print, 5³/₄ x 8¹/₈" (14.7 x 20.7 cm). J. Paul Getty Museum, Malibu, California.

Baron von Gloeden and F. Holland Day placed the homoerotic body outside their own cultures. Von Gloeden, who was born in Germany, photographed young men in Italy and Sicily; Day, a white American, photographed oriental and black youths. These male bodies are eroticized as "others," not only sexually, but racially.

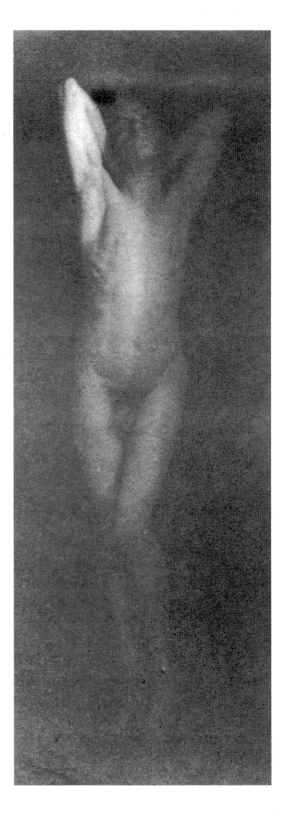

scenes from the Passion of Christ (FIGS. 36 and 37). The body is
of great importance throughout Christianity. Events from the
life of Christ allegorize philosophical and ethical concerns, with
a physical body at their center: the Birth, Crucifixion, Resurrec-
tion, and Ascension all occur in terms of Christ's body, which in
turn is remembered through the sacrament of the Eucharist, in
which according to the Roman Catholic doctrine of transub-
stantiation, bread and wine become the body and blood of
Christ. In his narcissism, Day puts his body into scenes from the
life of Christ, including depictions of the *Seven Last Words* and
the *Crucifixion* (1896). In this, and in his eroticization of young
boys, he revealed himself as one of the many photographers of
this period to be fascinated by the nature of transgression.

THREE

1900-1940: Heterosexuality and Modernism

38. MARGRETHE MATHER
(American, 1885-1952)
Untitled (Billy Justema's
back), c. 1923. Platinum
print, 3⁷/₈ x 3" (9.5 x 7.4
cm). Center for Creative
Photography, Tucson,
Arizona.

Like Cunningham, Margrethe
Mather constructs a male
body that is tactile rather than
visual – defined as a surface
of skin, and experienced
through touch, rather than
through the gaze.

Photographic nudes of the 1910s, 1920s, and 1930s were part of the new sexual freedom then emerging. During the period 1900-1914, popular culture and events at the fringes of society intimated that the independent but sober "new woman" of early Modernism would lapse into the sexually liberated flapper of the 1920s. The Russian émigrée and feminist Emma Goldman, who advocated free love, made New York's Greenwich Village, where she lived, a centre for the new sensuality. Men and women escaped the euphemisms of nineteenth-century sexual morality, and the female body gained greater freedom of movement and exposure. As these new freedoms spread through society, women's liberation received support from the followers of Freud, who recognized the existence of male *and* female sexualities. Reversing Victorian opinion, Freud deemed sex beneficial, and a source of pleasure apart from procreation.

However, Freudianism endorsed sexuality only if it were "normal," which meant within the institution of marriage, and heterosexual. Freudianism stigmatized homosexuality as "deviant." (The terms "homosexual" and "heterosexual" had been coined in the late nineteenth century, "homosexual" being brought into the language first, and "heterosexual" following it.) Each individual in society could now be defined not only by gender (female/male), but also by sexual preference (heterosexual/homosexual), and by implication, a value judgment ("normal"/"deviant"). As historians have noted, these labels influenced even the least sexual areas of human activity.

At the same time photography was becoming "modern." Conventional histories of the medium define the change as one of technique and style. From the 1880s through the first decade of the twentieth century, Pictorialists battled to achieve "art" status for photography by using soft-focus lenses, textured papers, muted tones, brushwork and scratches (to manipulate negatives and prints), and self-conscious borrowings from Impressionism, Symbolism, and other painting styles. In the 1910s and 1920s, modern photographers abandoned these affectations and instead embraced what they called "straight" photography, which was marked by the absence of manipulation, and by sharp focus, a full range of tones from white to black, and an independence from painterly prototypes. Modernist photographers claimed

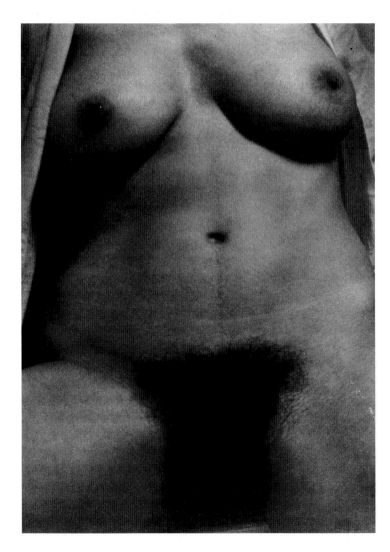

39. ALFRED STIEGLITZ
(American, 1864-1946)
Georgia O'Keeffe, A Portrait (Torso), 1918. Palladium print, 9³/₈ x 6⁵/₈" (24 x 16 cm). J. Paul Getty Museum, Malibu, California.

that they were recovering the "essential" qualities of the medium, demonstrated in mid-nineteenth-century photographs made without artistic ambitions (such as those seen in Chapter One). Post-structuralism questions this rhetoric of Modernism, which devalues Pictorialism and holds Modernism to be above style, and to be (somehow) something other than a reflection of the social values of its time. Re-evaluated through post-structuralism, early twentieth-century photographs of the body suggest the extent to which Modernism was historically and culturally determined.

During the period from 1910 to 1940, both male and female photographers fashioned their careers, and Modernism itself, around the power of their pictures to give form to heterosexuality. Modernist photographers produced an erotic female body that was exclusively heterosexual, which created for themselves a position that was "heterosexualized," whatever their actual sexuality might be. This preoccupation with heterosexuality (and the concomitant denial of homosexuality) became a touchstone of their skill and even of their commitment to Modernism. It is ironic that "unmanipulated" pictures were also labelled "straight." Submerged in mainstream Modernism was the homoeroticism that had flourished under Pictorialism, in the work of such photographers as Day and von Gloeden. Submerged as well was the world of women independent of men (and of the male gaze), as reflected in the photographs of Käsebier and Brigman.

American Formalism

The unmanipulated photographs of Alfred Stieglitz and Edward Weston from this period have come to be defined through a series of nudes (FIGS. 39 and 40). Weston, more than Stieglitz, seems as a Modernist to have removed the physical bodies from the psychological beings he photographed. For Weston, the female body was no more erotic an object than the peppers and halved cabbages that he also photographed at this time. Like them, it was a means by which he could define himself as a Modernist photographer.

Stieglitz, the great master of early Modernism, had already made several photographs of female nudes in collaboration with Clarence White. Between 1917 and 1933 he made numerous photographs of the American painter Georgia O'Keeffe, his lover and later his spouse. Stieglitz's portrayal of O'Keeffe is radical in its innovative definition of the role of the body in portraiture. Stieglitz thought that only collectively, as a body, did these photographs constitute a portrait of O'Keeffe, that they comprised a

singular portrait, rather than a series of portraits. This revelation of O'Keeffe's identity through repeated views of her body evokes the philosophical idea that human knowledge and experience are built up over a period of time. It also suggests the faceting of reality in the Analytic Cubism of Picasso and Braque of 1909-1911. Stieglitz may also have found inspiration in the sequential unfolding of narrative cinema, then reaching great levels of popularity. One of Stieglitz's radical innovations in this series was his cropping of the individual photographs to produce sexually charged, unnatural, decontextualized body fragments. For these prototypes also existed in contemporary cinema, in the full face close-up shot which Hollywood created in 1905. The most radical innovation in the O'Keeffe portrait was, however, the use of nudity. Neo-classicism had allowed Canova, early in the nineteenth century, to sculpt a nude Napoleon since it enabled the sculptor to idealize his subject as a Roman emperor, but such allegorical and classicizing portraits aside, to depict a known person in the nude in high art was most unusual. The popular culture of the period provides some models Stieglitz might have followed in defining a woman through erotically charged views of her body: female pin-ups were first seen on calendars during the decade before the first World War.

Stieglitz's portrait of O'Keeffe is gendered because she is represented through her sexual body parts. What makes the portrait such a photographic landmark is its unrepentant expression of patriarchal power over O'Keeffe's body, achieved through such Modernist gambits as fragmentation and repetition. Paul Strand's photographs from 1916 of down-and-out people on the streets of New York are, in their close cropping, models for some of the individual photographs within Stieglitz's portrait of O'Keeffe. Made surreptitiously with a prism in front of the lens, they owe much to early surveillance photography; for the latter to be connected with the photographs that Stieglitz made of O'Keeffe (and those that Strand made of his wife Rebecca) is to imply that the close cropping, suggestive of a lover's intimacy, subjects the love object to the eye of power.

But there is a different way of reading Stieglitz's portrait of O'Keeffe. O'Keeffe may not have been a victim of her lover's Modernist gaze, but someone who shrewdly exploited it. What other images could so well have promoted O'Keeffe as the archetypal woman artist? As defined by Stieglitz's portrait, O'Keeffe becomes her body, her sex and sexuality. Psychoanalytic theory suggests seeing phallic forms in O'Keeffe's upwardly thrusting body and in the dark shadow between her legs. Today,

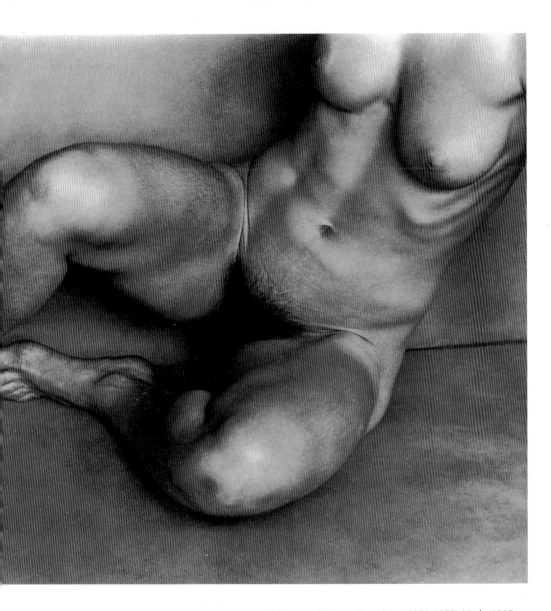

40. EDWARD WESTON (American, 1886-1958) *Nude*, 1927.
Silver print by Cole Weston, 1971, 6¹/₄ x 9¹/₄" (17.1 x
23.5 cm). Spencer Museum of Art, University of Kansas.

Despite the clinical perfection and detachment with which
Edward Weston's photography denied the subjectivity of
women, his nudes were central to the construction of *his*
subjectivity and *his* biography; in mid-life he rejected the
upper-middle-class respectability of married life for a
bohemian life of vegetarianism and free love.

her reputation is as an artist for whom her gender is essential rather than accidental. Her paintings of natural forms intentionally yield abstractions of female sexual organs, and her status as an artist is as a front-ranking twentieth-century American in the category "woman." Stieglitz and O'Keeffe may have worked together consciously to create her public persona, a possibility that would have paralleled the contemporaneous rise of the Hollywood star system, which was built on the close-up shot, the on-screen credit for individual actors, publicity photographs, and fan magazines. Even if Stieglitz's portrait of O'Keeffe did not derive directly from forms of popular culture, it can well be seen as having been legitimated and made legible by them.

Exceptions to the male view of the female body were to be found in the work of several photographers. Imogen Cunningham was well prepared to challenge conventional representations of the body. A free spirit and feminist, who constantly challenged social conventions, she had published in 1913 an essay entitled "Photography as a Profession for Women." In it she called for an end to the habit of stereotyping activities by gender. Bodies figure repeatedly in Cunningham's photography. Her early work shows the influence of those Pictorialist women photographers who had made the body a central theme in their work, including Käsebier (whom she admired),

Still from the film *The Big Swallow*, 1901.

Annie Brigman, and Alice Boughton. In 1915 Cunningham photographed her husband, the artist Roi Partridge, against the forests and lakes of Mount Rainier in Washington State. Like Brigman's *The Hamadryads*, Cunningham's photographs show their subjects nude, in nature, closely associated with natural things; they make Partridge seem a part of nature – holding onto a tree and leaning out from it, or kneeling in a pond and gently touching the water.

In 1926 and 1927, Cunningham began to make tightly cropped, sharp-focused Modernist pictures (FIG. 41) These might be taken to have inspired the close-cropped, highly abstracted female nudes made by Weston in the late 1920s, but unlike Weston, who photographed the female body exclusively, Cunningham continued to photograph the male body. During this period she also photographed female nudes. Cunningham's willingness to vary her subject, to photograph both along and across gender lines, sets her apart from Weston. (Feminist film theory would suggest that Cunningham could photograph both along and across gender lines because of the way that women are conditioned in patriarchal society sometimes to assume male roles.)

Margrethe Mather, like Cunningham, was typical of the independent-minded women who flourished in the 1910s and 1920s on the West Coast of America. Mather had become a photographer as an admirer of Käsebier, attended lectures in San Francisco by Emma Goldman, was an assistant to and probably lover of Edward Weston, and a friend of Cunningham. Her background divorced her from the conventions of society. An orphan raised in an adoptive household, she was a prostitute, a feminist, and, possibly, a lesbian. Her closest friend for many years was Billy Justema, an artist and kindred spirit who shared her devotion to sensuality. In her photographs, his body has a sensuality uncommon to men (FIG. 38). In a joint money-making scheme, they marketed erotic scenes drawn by Justema and copied by Mather as sumptuous platinum photographs. Both Mather and Justema inclined towards the Japanese-influenced aestheticism popular in the 1920s, and they kept the studio they shared a nearly empty space, bathed in bright but tempered sunlight.

Tina Modotti was Mather's successor as Weston's paramour. Italian by birth, she also spoke Spanish, and traveled with Weston in Mexico from 1923 to 1926. Modotti was very much a part of the radical upheavals in Mexico during the 1920s, in which modern art joined with leftist politics in an effort to forge for that country an independence at once cultural and economic. Modotti photographed the hands and the bodies of workers in

ways that emphasized the importance of their status as workers (FIG. 42). Close-cropped and close up, hands are shown caked with dirt, the skin deeply cracked, with the tools of manual labor close by. But the style of her pictures is without the self-conscious realism that would come to dominate social photography in the 1930s in the United States. Rather, like the Mexican muralists Diego Rivera and David Alfaro Siqueiros, she found in Modernism a language to express a break with the past and the hope for a new world.

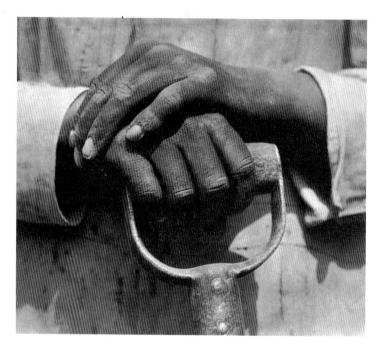

Surrealism in Europe

European Modernist photographers, who were more influenced by Surrealism than were Americans, also used the female body as a means of marking out their espousal of the avant-garde. As a means for achieving the goals of Surrealism, photography surpassed painting, as it presented an automatic trace, an indexical presence of some original, rather than a reasoned representation of it.

Working in France, André Kertész made a series of photographs in 1933 in which he distorted nude female bodies in a curved mirror (FIG. 43). His use of a mirror produced images in which doubling may have been an intentional element, rather than mere accidents within the automatic processes exploited by

Above left 42. TINA MODOTTI (Italian, 1896-1942) *Number 21, Hands Resting on Tool*, n.d. Gelatin-silver print, 7³/₈ x 8¹/₂″ (18.9 x 21.6 cm). The Museum of Modern Art, New York.

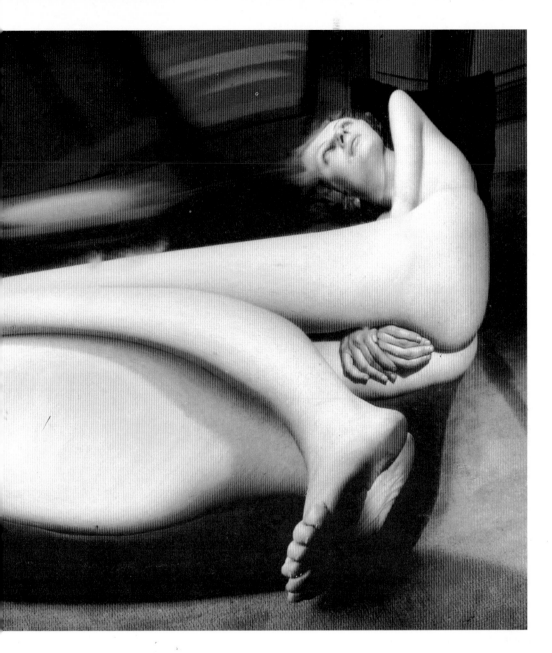

43. André Kertész
(American, b. Austria-
Hungary, 1893-1985)
Distorted Nude, 40, 1933.
Silver print, 8 x 10¹/₈″ (20.3
x 25.4 cm). Spencer Museum
of Art, University of Kansas.

other Surrealists. The curved mirror eradicates any clearly
defined perspectival space separating photographer and viewer
from the model. The body seems not just elastic or rubbery, but
unstable, unfixed, denying the viewer a single, fixed vantage
point. Kertész's distortions are formally innovative, and quite
different from Stieglitz's static photographs of O'Keeffe. But
they share with Stieglitz's pictures the control of a male photog-
rapher over a female body. In the "hands" of Kertész the female

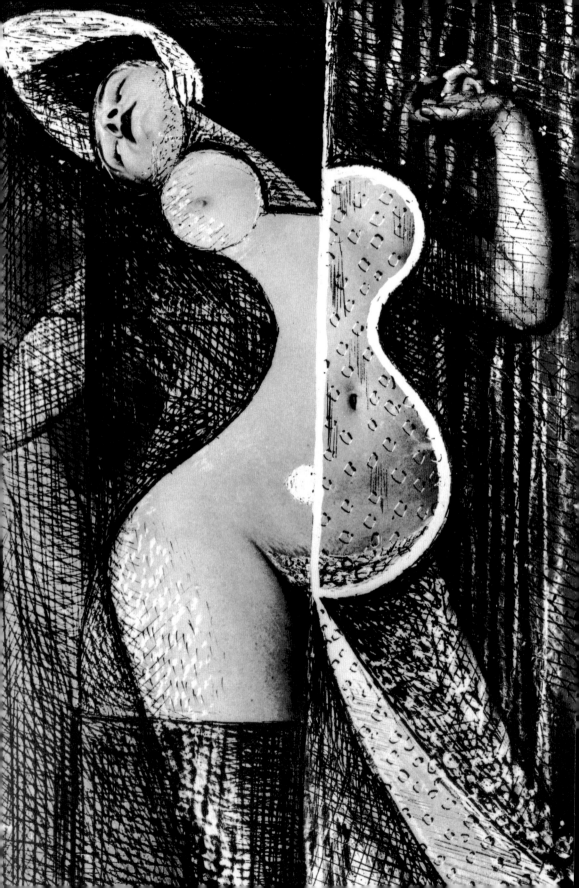

body becomes something close to putty, without bone or muscle or spine to exert its own will. In one photograph from the same series, the mirror reveals not only a nude model, but Kertész himself, at work with view camera on a tripod. The female model is unclothed and distorted, whereas Kertész is clothed, his body clear and coherent; only his head is slightly blurred. The model exists only passively, to show her body, while Kertész is at work, actively pursuing his art. In addition, Kertész is in the dark, looking at the model, who is in the light. He is a voyeur, looking into a lit room, or a viewer of a film, looking up at a brightly lit projection screen in a dark auditorium.

Opposite 44. Brassaï (Gyula Halàsz; French, b. Hungary, 1899-1984) *Odalisque (Woman of the Harem)*, 1934-1935. *Cliché-verre*, 9³/₈ x 7" (23.9 x 17.8 cm). Spencer Museum of Art, University of Kansas.

45. Hans Bellmer (French, b. Germany, 1902-1975) *La Poupée*, c. 1935. Silver print, 4⁵/₈ x 3¹/₈" (11.5 x 7.7 cm). Spencer Museum of Art, University of Kansas.

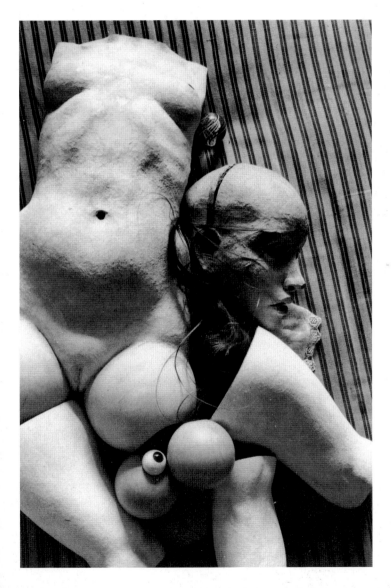

Viewers can approach this photograph in a number of ways, but all constrain them to view as if they are male. One can relate narcissistically to Kertész, and through him enjoy and control the female model. Or, the female model can be enjoyed directly, voyeuristically, as if she were a two-dimensional icon. This places the viewer in a position parallel to that of the photographer. In this *mise-en-scène*, as in some conventional narrative films, the female model has no role, no action, no purpose, other than to be observed. She possesses neither agency nor subjectivity, being subject only to the looks and actions of others.

At the same time that Kertész was making his *Distortions*, the photographer Brassaï (Gyula Halàsz) was making a series of works he called *Odalisque* (*Woman of the Harem*) (FIG. 44). These works were *clichés-verres*, made by drawing on glass and using the marked pieces of glass as negatives for photographic prints. In taking up the theme of the odalisque, Brassaï was returning to a subject frequent in popular French art from Ingres and Eugène Delacroix to Henri Matisse. The odalisque theme doubly subordinates its subject – not only is a female body viewed by a male, but an oriental body is viewed by a European.

On a slightly different note, the dispirited, unanimated physical form of the body held an important position within the aesthetics and philosophy of Surrealism. In Surrealist art the female body often appears in the form of a manikin, the anatomical form used to display clothing. Surrealist artists took the manikin from their Dada predecessors, using it to represent the generation born after the first World War, described by T. S. Eliot in his 1925 poem as "The Hollow Men." Eliot's imagery conjures up the empty bodies of "stuffed men": "Shape without form, shade without colour, /Paralysed force, gesture without motion." In a challenge to logic, the Surrealists replaced live bodies in their art with inanimate manikins.

The most notable European Surrealist photographer to work with manikins was Hans Bellmer. In the mid-1930s Bellmer built a small doll with articulated joints, which enabled him to change its position endlessly. He called it *La Poupée* (the doll) and photographed it repeatedly (FIG. 45). Bellmer appears at first to be a male artist using the female body as the means for his transgressive actions. But unlike photographers who present themselves as members of the avant-garde by treating the female body without conventional respect, Bellmer (and other Surrealist photographers) seem to be admitting that the female body already exists as a representation. Bellmer's photographs produce a female form that is without life, essence, or soul, but which is subject to

a constant repositioning within the male narrative of fantasy, literalizing the objectification of the female body that is produced by the male gaze. He admits to (and incidentally deconstructs) the psychological process of objectification.

Masquerade

Moving from the artistic circles of Paris and New York to southern California, one encounters the photography of Paul Outerbridge, Jr. Outerbridge learned photography from Clarence White in New York in the early 1920s, and from 1925 to 1929 he worked in Paris, where he came to know Man Ray, Francis Picabia, and Marcel Duchamp, all of whom had been Dada artists and then Surrealists. In the 1930s he produced color photographs with intense hues, using the carbro-color process, an extremely complicated technique requiring him to make separate red, blue, and yellow images and then superimpose them. Among these are images of women's bodies in fetishistic poses and situations. Many are without pubic hair. Whether done

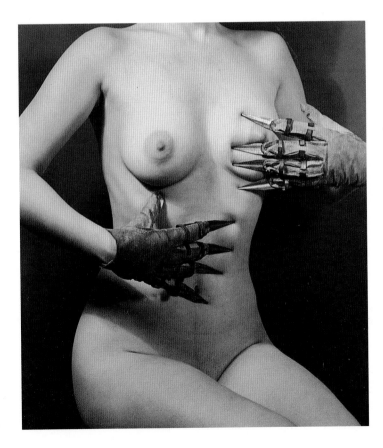

46. PAUL OUTERBRIDGE (American, 1896-1958) *Nude Woman Wearing Meat-Packer's Gloves*, c. 1937. Carbro-color print, 15⅝ x 9¾" (39.7 x 24.8 cm). J. Paul Getty Museum, Malibu, California.

before the exposure, with a razor, or after, with an airbrush, the act of removing pubic hair robs the body of a sign of its sexual maturity, infantilizing it and making it less threatening to men. Outerbridge's *Nude Woman Wearing Meat-Packer's Gloves* (FIG. 46), a carbro-color print from around 1937, shows a masked woman wearing meat-packer's steel-tipped gloves, with which she touches her breasts and stomach. The picture is complex and contradictory, suggesting both fetishistic overvaluation and sadistic devaluation. The model seems totally submissive to male desire. She puts on display her whole body, which has been fetishized by the photographer, and she also entertains male viewers' sadism with masochistic acts, as she fingers her own soft flesh with the metal tips of the meat-packer's gloves.

However, there is another way to read the role of the female in this image, one that incorporates ideas of the masquerade, a theme that appealed to the Surrealists and which has been revisited by feminist theorists. Women use clothing, make-up, hairstyle and color as tools to alter their appearance in an infinite variety of ways. They can hide behind such a masquerade, using it to deflect the male gaze and to find a space in which they can act freely. This argument inverts the power relationship of Outerbridge's photograph. The female model is no longer pandering to male desire, but is constructing, through alterations (mask, gloves, shaved pubic hair) a simulacrum, an artificial "other" that both satisfies and staves off the male gaze and the male desire for sex and power. When Outerbridge matted the picture, he cropped it at the top, taking out the woman's head and the mask she wears over her eyes. The mask underscores the figure's inability to return the objectifying male gaze; but it also provides a masquerade by which she eludes that gaze and a subterfuge by which she can, in fact, return it.

The power of masquerade to subvert the male gaze is also exploited in a 1928 photograph by Florence Henri (FIG. 47). Her *Self-Portrait* is another example of a photograph made of an image reflected in a mirror. The vertical shape of the mirror may be intended to suggest a phallus, an interpretation strengthened by the placement of the two balls at its base. The idea here is that Henri, by showing herself dressed, imitates the construction in the visual arts of male identity being found in a clothed body. As has been said, the heterosexualized male body is rarely shown explicitly; its presence is usually implied through its power – often its power over women and their bodies. The male sex organs that Henri gives herself metaphorically are sources of two types of male power, aggression and procreativity.

47. FLORENCE HENRI (French/German, b. United States, 1895) *Self-Portrait*, 1928. Gelatin-silver print. Galeria Wilde, Cologne.

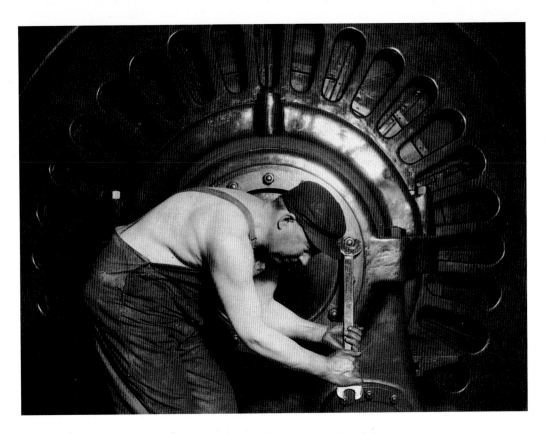

What of the construction of the male body during the same period? It would be inaccurate to see the female body as constructed and the male body as somehow more natural in its representation. Some especially interesting photographs of the male body undermine its naturalness, and cut through the culture that sees as normal the ordinariness of masculinity.

In addition to being defined by its power to control women and their bodies, the masculinity of men and the male body is characterized by its power to control and manipulate (other) things. The seemingly natural activity of the male body – performing physical labor – is the ostensible subject of *Bolting Up a Big Turbine* (FIG. 48), a 1920 photograph by Lewis Hine that shows a laborer at work. His thighs, back, and head link with the wrench he wields to form a curve in harmony with the bold geometries of the turbine itself, an aesthetic statement by which Hine, a committed liberal reformer, argues the potential harmony of man with the machine.

But there is something amiss in this picture, and it has to do with power and the body. The photograph refuses to collude in Hine's intention to represent the harmony possible in working-

48. LEWIS HINE
(American, 1874-1940)
Bolting Up a Big Turbine,
1920s. Silver print, $7^1/_2$ x
$9^1/_2$" (19.2 x 24.2 cm).
Spencer Museum of Art,
University of Kansas.

Lewis Hine has photographed this worker in a position defined not by common sense, but by the dictates of modern formalist aesthetics. The man has very little power over the bolt; he would be able to exert more power if he repositioned the wrench a quarter turn to the horizontal, and then re-engaged the bolt.

class labor. The workman is clearly in the wrong position to work the bolt, and the existence in Hine's oeuvre of other, similar pictures of men in front of turbines, performing similar actions, reveal this picture as being set up. The true power at work here is that of class. As a worker, this man does not have access to the power of self-representation; he has to be represented for public consumption by the social reformer Hine. His role as a working person is merely acting. It is not his subjectivity that is represented, but only his body, through which Hine seeks to support both the aesthetics of Modernist formalism and the politics of progressive liberalism.

It may be that Hine wanted his photograph to be seamless, to conceal the gap between reality and the image he sought to produce of a worker in perfect harmony with his machine, depicted in a graphically powerful, formally satisfying pose. But the photograph is not seamless, and to the extent that it comes into being in the gap between what was wanted and what was realized, it suggests the inherent inadequacy of representation.

The question of a coherent, fixed identity reappears in a group of photographs made by August Sander in Germany in the 1920s (FIG. 49). Sander functioned like a taxonomist. He used photography to collect samples of various types within German society and arranged them in an ordered scheme. In his photographs the person's body and profession reinforce each other. The form the body takes seems not accidental to the work performed, but essential to it; conversely, the occupation seems essentially part of the person and the body. Sander constructs each picture in the series with the body centered in the frame and more or less the same amount of space around each one. These similarities are especially apparent if one flips through the photographs as they were published in a book, designed according to Sander's wishes. As in Muybridge's photographs, the presence of only subtle distinctions from body to body serves to emphasize the overall unity of the *oeuvre* as well as of the people represented therein. A stylistic subtext to Sander's work is the similarity of humankind, or at least of the German people.

But the people that Sander photographed, the young ones in particular, suggest through their poses that they are acting themselves and their professions for his camera. The photographs then read as records of performances – countering the assertion that the bodies are inherently linked to each individual's profession. However, these two points may not be contradictory. The performance of one's self, one's gender, and one's profession may be all that there is, with no fixed, coherent centered self.

49. AUGUST SANDER
(German, 1876-1964)
Students: Gymnasium Student, Cologne, 1926.
Gelatin-silver print. Sander Archiv, Cologne.

Acting Out

Ambivalence about modernity and the liberation of the individual from social constraints racked European and American culture in the 1920s. An aspect of this is recorded in a work by an unknown photographer entitled *Ku Klux Klan Group at Train Station, Topeka, Kansas, September 15, 1923* (FIG. 50). The Klan, formed in the American South during the Civil War as a white supremacist group, re-emerged in the 1920s in the North, amidst hardening racist and anti-immigration attitudes. In this photograph the body is conspicuous by being hidden. Like the National Socialists of Germany, who censored Sander's work for its seeming critique of German society, the Klan was racist and nationalist. Its members adopted the white robes and hoods seen in the photograph to hide their identities, but this costume was also intended to scare and intimidate the unempowered African Americans who were the victims of Klan activities.

The process of acting out was adopted as a male strategy in a different context by the Austrian painter Egon Schiele. In an untitled work from 1914, Schiele is clearly acting for his own photograph (FIG. 51). He does not subscribe to the notion that he can depict a real or natural self through photography. With his fellow Viennese, Sigmund Freud, Schiele sees the "real" self as existing in the unconscious, under layers of actions and defensive postures. Instead of seeking any illusion of a real or natural self, Schiele performs for the camera, suggesting that selfhood and gender are realized only through performance. Schiele not only acts within the photograph, but also collaborates in the

50. PHOTOGRAPHER UNKNOWN *Ku Klux Klan Group at Train Station, Topeka, Kansas, September 15, 1923.* Gelatin-silver print, 5 x 7⅛" (12.7 x 18.1 cm). Kansas Collection, University of Kansas.

Opposite 51. EGON SCHIELE (Austrian, 1890-1918). Untitled, 1914. Watercolor on gelatin-silver print by Anton Trčka or Johannes Fischer. Albertina, Vienna.

trangression of its surface. He marked the gelatin-silver print of the photograph, which was made by either Anton Trčka or Johannes Fischer, with watercolor, thus repudiating one of the dictates of "straight" photography: that to be modern photographs should reveal, rather than obscure, their origin in modern, mass-produced materials, which are uniform and show no handwork of the maker.

Schiele made this photograph at a time when a newly dominant photographic aesthetic was demanding a rigorous separation of photography from painting. Any handwork on either the negative or print, intended to enhance its status as a work of art, was denounced. Yet despite this manipulation, or perhaps because of it, Schiele's photograph – in its construction of the human body and the persona of the artist – is more modern, more avant-garde than the work of Stieglitz and his colleagues. Stieglitz's serial portrait of O'Keeffe, flaunting his control over O'Keeffe's body and sexuality, correspondingly defined his position as the masculine and heterosexualized maker. Schiele abandoned all claims to such a position and, within the tenets of romanticism that persisted in high Modernist art, thereby also abandoned the most easily recognizable means of proclaiming himself exceptional, an artist. Instead he made himself the object of his own photograph and deliberately risked his own status as heterosexualized and masculine.

Another photographer who assumed an equivocal artistic posture with his male body is Herbert Bayer, in his photomontage *Self-Portrait* (FIG. 52). This work is unusual in its fragmentation of the body, making it seem, as it is in Bellmer's *La Poupée* photographs, artificial and plastic. Bayer's body really does appear to have been denaturalized through the process of montage. One of the attractions for transgressive Modernists in photographic montage and photographic collage is the ability of these processes to deconstruct and denaturalize the apparent realism of photographic representation. Collage tends to destroy the illusion upon which traditional perspective depends, and consequently it serves to decenter the viewer. In Bayer's work, however, a form of perspectivalism is reinstituted through the use of a mirror. The creation of a spectral image in the mirror places photography's own process of representation within the photograph, similar to the literary device that the French philosopher Roland Barthes has labeled *mise en abyme*, in which the meaning and process of a complete work are restated in miniature within the work itself. The image doubles over on itself.

52. HERBERT BAYER (American, b. Austria, 1900-1985). *Collection Self-Portrait*, 1932. Gelatin-silver print from rephotographed photomontage, 13³/₈ x 9¹/₂″ (34 x 24 cm). Cincinnati Art Museum.

Aus der Sammlung: Aus einem ethnographischen Museum. DENKMAL II. '26 EITELKEIT!

1900-1940: Heterosexuality and Modernism

The process of viewing the photograph is also restated in the photograph itself, but with a significant variation on the conventional order, in which the (male) photographer's actions upon the (female) subject represent the desires of the (male) spectator. Here, both roles within the photograph are assumed by a male – in fact the same male, because one is the reflected image of the other. Like Schiele, Bayer has found a way to subvert the convention that the male body should not be the object of the gaze. The heterosexualized male viewer is protected against any engagement with the male body in the photograph because that body seems totally absorbed by the gaze enacted within the image itself.

Surrealist photographers tried to make their photographs appear seamless, even those manipulated with scissors and paste (collages) or in the camera and darkroom (montages), so that they presented a reality at once coherent and strange. Bayer and other German photographers were more concerned with seeing the everyday world in new ways, to create what they called "the new vision." For them it was important that their techniques of deconstructing the visual world be obvious. Photographs that tore apart and reassembled visual reality were intended by these politically committed artists to suggest that society itself could be radically changed. Hannah Höch provides another example of a photographer who, like Bayer, recycled published pictures to create obviously recrafted imagery (FIG. 53). In her work, collage fractures the totalizing power of the gaze and allows the production of bodies that are deliberately created, rather than existing solely to be viewed. Like the masquerade, montage was a strategy to claim power and subjectivity.

53. HANNAH HÖCH (German, 1889-1979) *Denkmal II: Eitelkeit (Monument To Vanity II)*, 1926. From the series *Aus einem ethnographischen Museum*, 1926. Collage, 10 x 6½" (25.8 x 16.7 cm). Rössner-Höch, Tubingen, Germany.

FOUR

1930-1960: The Body in Society

P hotography of the 1930s, 1940s, and early 1950s was intimately connected to the Depression, the Second World War, and the early years of the Cold War. During the first half of this period, the body in photography was chiefly portrayed in terms of class, race, and nationhood; only later was it (once again) defined in terms of gender.

The seemingly transparent realist style that dominated photography of the Depression was constructed around the bodies of people dispossessed by class or race. This is fully demonstrated in the photographs of white sharecroppers made by Walker Evans in 1936 in the southern United States for the book *Let Us Now Praise Famous Men*, on which he collaborated with the writer James Agee. These pictures were influenced by Evans's reading of the great nineteenth-century French novelists during a year he spent in Paris in the late 1920s. Scholarship has claimed that Evans took from Flaubert a "reverence for [the] religion of disinterested art" and from Baudelaire a "fascination and disgust with modernity." As a consequence, Evans stayed outside the radical politics of the 1930s which criticized American capitalism. Instead, as an artist and aesthete (and a scion of a well-off family), he participated in efforts to create a viable American culture, a fiction of a coherent, unified America. Evans found in America's rural poverty, as he had on Paris's Left Bank, a kind of antidote to the financial excesses and moral

insensitivity that had ruled Wall Street and the American econ-
omy during the 1920s. The photographs that he made in
Alabama show his belief that poverty was noble and aesthetic,
full of morality and dignity. To express these ideals, Evans
deploys the figures in *Sharecropper's Family, Hale County,
Alabama* (FIG. 55), for example, laterally across the image with
puritanical solemnity, as if the individuals depicted here were
posing for a series of tintype portraits. The rigorous frontality
and isolation of these figures distinguishes Evans's picture from
works such as Hill and Adamson's group portrait (see FIG. 5), in
which informal conviviality is expressed through actual physical
contact between bodies. The dispassionate rigor of Evans's pho-
tographs also distinguishes them from other photographic works
of the Depression era, which seek to evoke sympathy, and to
provoke the viewer to action that would change social condi-
tions.

The Great Depression, Class, and Liberal Politics

Despite claims of political disinterest, Evans nonetheless pro-
duced in his photographs numerous references to social class.
The bodies in *Sharecropper's Family* are crucial markers of these
people's identity. They derive their income from the gross phys-
ical efforts of their bodies, and they cannot be photographed
without revealing to the camera signs of the hard work, malnu-
trition, and inadequate medical care of their class. As a further
sign of their low social status, these sharecroppers are repre-
sented without conventional middle-class decorum, or even
decency. They control nothing of their own representation.
Their home, their flesh, even the son's genitalia, are laid bare to
the camera's piercing eye. Like Frith's Indian men (see FIG. 8),
the members of this family are specimens under scrutiny, cen-
tered in the frame, who succumb to the researcher and pose pas-
sively for the picture.

Although there are residual signs of his status as the family
patriarch (placement in the center of the group, identification in
the photograph's title), the sharecropper himself is stripped not
only of his shirt, but also of his masculinity. He is photographed
not within the public space of characteristically male activities,
but within the domestic space of his home. He is shown not in
the midst of action, another means of male self-definition, but in
the passive role of someone who is looked at. Thus regendered,
his body stands for the economic conditions that rob him of his
role as the family breadwinner.

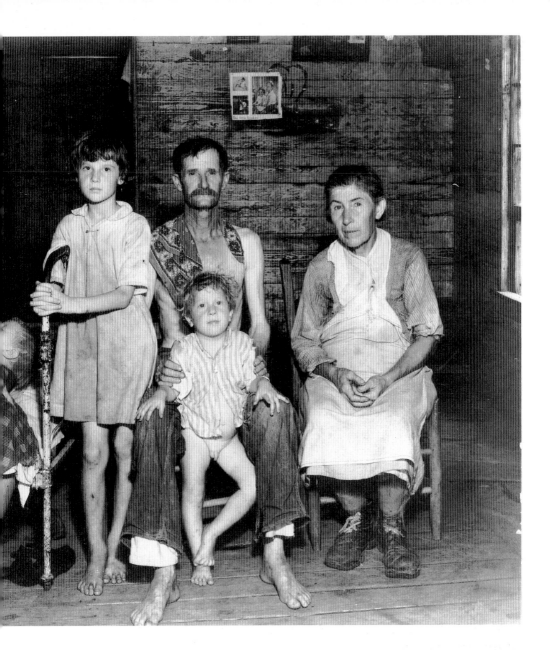

55. WALKER EVANS (American, 1903-1975) *Sharecropper's Family, Hale County, Alabama,* 1936. Silver print, 8 x 9³/₈" (19.9 x 23.8 cm). Spencer Museum of Art, University of Kansas.

The status of these family members as subjects of a photographer's gaze is repeated in the tearsheet of photographs pinned to the wall behind them. But in poignant contrast to Walker Evans's photograph, which displays the poverty of the sharecropper's family, the clipping on the wall shows a conventionalized middle-class representation: posed in the clean, well-lit space of a home or photographer's studio are a blond young boy, in short pants and a nice shirt, and in his lap a younger child, presumably his sister, equally healthy, well-scrubbed, and smiling.

56. Dorothea Lange
(American, 1895-1965) *Migrant Mother,
Nipomo, California,* 1936. Gelatin-silver print.
Library of Congress, Washington, D.C.

For photographer Dorothea Lange, bodies function differently. Like Evans, Lange was a photographer for the Farm Security Administration, a program of the federal government intended to blunt the effects of the Depression on rural Americans. The FSA wished to create an image of a unified nation. The pictures it produced were intended to represent the United States as a series of homogenous entities – *the* American farm, *the* American small town, *the* American family – rather than to explore the complexity and multiplicity concealed by such generalizations. Lange was more political than Evans, and her photographs are more openly expressive than his. In contrast to Evans's critical, analytical, distant photographs, Lange's are empathetic, involved, emotional. Evans photographed people as frozen specimens, whose identity is etched onto the surface of their bodies, on the very skin that defines their limits and contours. In her photographs, Lange defines bodies less through such seemingly essential characteristics than through actions and gestures. Whereas Evans derives the significance of his photographs from the very presence of bodies, and his deadpan scrutiny of them, Lange creates meaning more directly, through bodily gesture. Using a camera held at waist level, she frequently placed the figures she photographed against the sky, towering boldly over the viewer.

Lange constructed photographs around both male and female subjects, but her best-known work, *Migrant Mother, Nipomo, California* (FIG. 56), centers on the female body, the body that is socially constructed through the gaze, and has the quality "to be looked at." In *Migrant Mother*, Lange builds a narrative around a woman and her three children, centered on the single gesture of an upraised arm. As the two older children turn their heads away from the photographer (out of shame or shyness?) and an infant child sleeps, the mother alone remains awake and vigilant. Her arm is upraised, not to support her head but to finger her chin in tentative thought. The picture is created around certain notions of the female body, including the idea of the nurturing mother. Lange drew on traditional images, such as Renaissance depictions of the Virgin and Child and the secularized versions of these that began to appear in the mid-nineteenth century with the rise of the Victorian cult of domesticity. Moreover, even though *Migrant Mother* was made in a public space, the close cropping of the image creates within the frame itself a protected, interior, feminized space.

Working independently in New York in the 1930s, Helen Levitt created images that speak of a more optimistic view of

57. Helen Levitt
(American, b. 1913)
New York, c. 1942. Silver
print, 6½ x 9½" (16.5 x 24
cm). Spencer Museum of Art,
University of Kansas.

childhood. Her photographs of children at play in the urban
density of New York City ignore the larger social ills of poverty,
the rise of fascism, and the threat of war to depict a world that
seems free of anxieties. In *New York* (FIG. 57) the body is pre-
sented as a vehicle for freedom and play, as the three boys run
about an empty parcel of land. Levitt saw children's play as
physical, centered in the body itself, not in the mind or emo-
tions, and she drew attention to its physicality, its very location
in the body, by placing the figures within deep and clearly
defined three-dimensional spaces, which the bodies of the chil-
dren then command with a theatrical presence.

Other documentary photographers used the body to investi-
gate issues of race and discrimination. While ideas of what con-
stitute race and racial difference change from generation to gen-
eration, and from culture to culture, they have always been
inseparable from the body, for the most obvious manifestation
of race is skin color. Gordon Parks joined the photography unit
of the FSA in its final years (the early 1940s), as its first African-
American photographer. He later found popular success as a
photographer for the leading American picture magazine, *Life*.

In the pictures he made for both the FSA and *Life*, Parks addressed the bodily nature of race and racism.

In order to bear witness to the racial discrimination he had experienced while working for the FSA in Washington DC, Parks made several pictures that he hoped would show the devastating effects racism had on its victims. One of these was *Black Children with White Doll* (FIG. 58), which shows two actual bodies plus the simulacrum of a body, a white-skinned, blond-haired doll. This doll functions similarly to Bellmer's *poupée*, reminding us that the bodies of the two little girls in the photograph already exist in representation and apart from their own subjectivity. They play with a doll not of their own race, but of the dominant, white race. The picture paralleled research being conducted at the same time by the African-American psychologist Kenneth B. Clark, aimed at understanding the development of racial identification in young children. When asked to choose the better doll, young African-Americans picked the white one, saying that it would be happier in life.

The question of race and the body was also addressed in photographs from the later 1940s by Marion Palfi. In *Georgia Study*

58. GORDON PARKS (American, b. 1912) *Black Children with White Doll*, 1942. Gelatin-silver print, 10⅛ x 13½" (25.4 x 34.3 cm). Spencer Museum of Art, University of Kansas.

59. MARION PALFI
(American, b. Germany, 1907-1978) *Georgia Study*
(A Gullah Family), 1949. Silver print, 13⅝ x 10⅝" (34.6 x
27 cm). Spencer Museum of Art, University of Kansas.

(FIG. 59), the black body is made to seem "normal" through the comparison implied in the picture's title and composition between this modern-day coupling and the Virgin and Child of Christian iconography. Yet it is the very vulnerability of these two figures that gives Palfi's photograph its greatest strength, both as a picture and as a damning critique of the effects of racism. The bodies depicted here are powerless, wounded, vulnerable. The mother does not seem able to protect her child adequately, while the child is nonetheless totally dependent upon whatever strength and sustenance the mother can provide.

Collectivity and the Era of the Second World War

In the late 1930s and early 1940s, as fascism threatened democracy, a different sort of body emerged in photography: the collective, political body. Two photographs of large crowds, gathered for very different reasons, bespeak this cultural moment. They served unintentionally as propaganda for collective action against fascist aggression worldwide. *Right of Assembly* (FIG. 54) by Arthur Siegel shows a 1938 strike in Detroit, Michigan, at a Chrysler Motors Company manufacturing plant. It ignores the efforts of industry throughout the 1930s to break the power of labor unions, and was reproduced widely to document the freedom of public assembly guaranteed in the United States Bill of Rights. Siegel's picture represents the possibility of group action, upon which collective bargaining and the labor movement are founded. At odds with the very democracy it seeks to honor, the picture rules out difference and nonconformity. The individual has no uniqueness, and is only another head in a great dark sea. The bodies in the photograph are gendered, for the people here assembled are all men, recorded as taking action in a public space.

A different collective body appears in the public space of *Coney Island Beach*, by Weegee (Arthur Fellig, FIG. 60). The picture, taken on the eve of America's entry into the Second World War, presents a scene that would very soon be lost. Weegee took the photograph from a vantage point above the assembled multitudes at the largest public beach accessible by the New York City subway system. Unlike Siegel's strikers, who are at a distance and unaware that they are being photographed, Weegee's bathers turn to him, posing, waving, and smiling. They offer up the flesh of their nearly bare bodies to the camera just as they do to the sun, and the bodies they offer up are bodies at leisure, displayed in the pursuit of relaxation and pleasure.

Overleaf 60. WEEGEE (Arthur Fellig) (American, b. Austria, 1899-1968) *Coney Island Beach, 4pm, July 28, 1940*. Silver print, 7½ x 9¾" (19 x 24.7 cm). Spencer Museum of Art, University of Kansas.

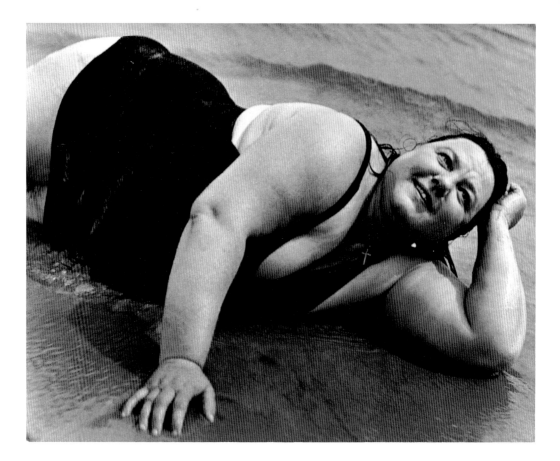

61. LISETTE MODEL
(American, b. Vienna,
1906-1983)
*Coney Island Bather, New
York*, between July 1938 and
1941. Gelatin-silver print, 15½
x 19" (39.4 x 49.5 cm).
National Museum of Canada,
Ottawa.

This mid-twentieth-century body rejected the nineteenth century's cover-all bathing costume, and even the contemporary suits of Siegel's assembled men. Instead, it welcomes the rays of the sun – and the gaze – to all but its most private parts. Such public spaces in the nineteenth century were segregated by gender, but this beach welcomes women and men, in clothing that accentuates gender differences.

The photographs of Lisette Model, who fled Vienna after 1937, first to France and then to New York, also display the recreational body. Model worked for newspapers and magazines, and was a genius at capturing body language; she did not use gesture, unlike Lange, but the expressive potential of the body's very mass. Her *Coney Island Bather, New York* (FIG. 61) is the antithesis of Weegee's beach picture in that it depicts a single body, not a large group. The weight, the flesh, the lack of perfection of her subject mark it not as a bathing beauty but a real flesh-and-blood person. Like Levitt, Model used the individual body for its expressive potential. Weight and form give Model's

bather presence, and seem to position it within a long line of bodies, painted by Titian, Rubens, Goya, Manet, and Matisse. Does something change here, now that this body is depicted by a woman and not a man? Through her graphically powerful and socially satirical pictures and through her teaching from 1950 at the New School of Social Research in New York, Model greatly influenced a younger generation of photographers, most notably Diane Arbus.

The photographs by Siegel and Weegee can also be seen as describing the massing of bodies that was part of the international upheaval of the Second World War. Unlike nineteenth-century wars, which were covered extensively by photographers because governments did not yet know to censor their activities, the two World Wars of the twentieth century produced few photographs of the effect on the body of the cruelty of war. In the case of the Second World War, it was only in 1943 that the United States government recognized the propaganda value of photographs showing the bodies of dead Americans. The greatest contemporary sacrilege to the human body was the Holocaust, the systematic extermination of the Jewish people in Europe carried out under the orders of Hitler and the German National Socialist Party. When only the written word reported them, the atrocities of the Holocaust remained unfathomable. It was the publication of the first photographs from the liberated camps that made the unthinkable devastatingly real. Photographs such as those made by the British photojournalist Lee Miller at Buchenwald and Leipzig-Mochau in 1945 (FIG. 62) shaped both world opinion and world emotions.

In the 1950s, the body as defined by photography, at least in the United States, began to change. This was in part the result of a change in social and economic conditions. During the Second World War, women had been called into jobs that previously had been off limits to them, hired by factories to replace a male workforce now serving in the armed forces. Some women took on support roles within the armed forces themselves. The fictional character of Rosie the Riveter, a figure in the US government's wartime propaganda, epitomized the new role that women had found in society. In the years following the war, however, women lost this new freedom and responsibility. In the late 1940s and early 1950s, the American economy was expanding, but not fast enough to keep women in the workplace and absorb servicemen returning home to reclaim old jobs. Women were encouraged to return to the home, to free up jobs for men and to help stimulate the economy by releasing a

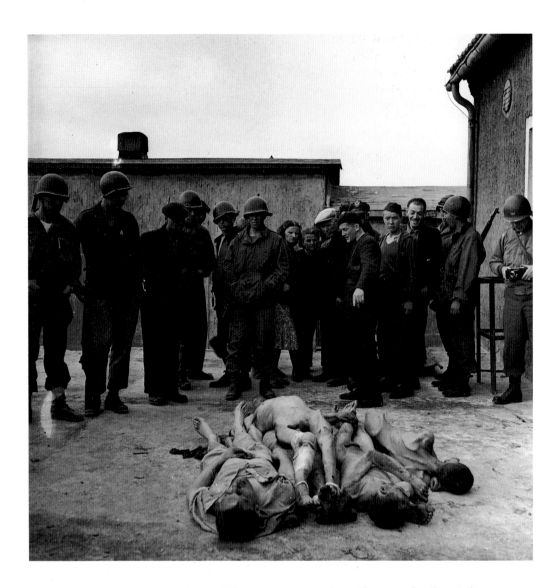

62. Lee Miller
(1907-1977)
Buchenwald, 1945. Gelatin-
silver print. Lee Miller
Archives, East Sussex.

demand for consumer goods, with every family needing a car, a refrigerator, a washing machine, and countless other consumer durables. Through this strategy the Eisenhower administration hoped to maintain full employment by replacing military production with a strong civilian market. The body and photography came together around this issue most obviously in fashion photography. Having already largely replaced hand-drawn illustrations in the 1920s and 1930s, photography was used to illustrate fashion in mass-marketed magazines during the Second World War and in the post-war era. Fashion photographs enticed women away from the utilitarian clothing appropriate to the workplace and rekindled in them a desire for finery. It was in the

early post-war period that Richard Avedon, Irving Penn, George Hoyningen-Huené, and Louise Dahl-Wolfe, among others, came to dominate the world of fashion photography, creating fantasy bodies, clothed and constructed through all the newest styles (FIG. 63).

63. GEORGE HOYNINGEN-HUENÉ (American, b. Russia, 1900-1968) Untitled, c. 1950. Silver print, 11¼ x 8″ (28.3 x 20.5 cm). Spencer Museum of Art, University of Kansas.

Sexual Orientation and Domesticity during the Cold War

Men's struggles to re-assert control over women in the post-war era is even more evident in the photography of Harry Callahan. Suggesting a return to the Victorian cult of domesticity, Callahan's photographs constructed the perfect 1950s family around

the bodies of his wife, Eleanor, and daughter, Barbara (FIG. 64). Eleanor appears disrobed at home, alone or with Barbara, who is also unclothed, in the Callahans' simple bedroom. These pictures identify domesticity as an aspect of the body itself, and exclude all quotidian activities. When inside, these bodies touch, caress, and sleep; outside, they bask in the sun, stand, and pose. They do nothing other than pose for the camera. They exist in these photographs with no center or purpose of their own, but only to satisfy Callahan's needs and desires as father, husband, and, foremost, photographer.

In creating a mythic world of domestic perfection, Callahan's photographs attest to his own heterosexuality. They helped to create the notion of superiority of straight, white men within American culture of the 1950s. In some ways this is a return to the issues raised by Stieglitz and other early twentieth-century Modernists, who simultaneously claimed avant-garde and heterosexualized status in their photography of the female body as a defense against the changing status of women in society. In the 1930s and 1940s, the threat to the stability of society posed by economic hardship and war perhaps excused a rearguard movement to restore patriarchy; the crisis conditions demanded straight men to solve society's problems; hence the suppression of women,

64. HARRY CALLAHAN (American, b. 1912) *Eleanor and Barbara, Chicago,* c. 1954. Gelatin-silver print, 6⁷/₈ x 6¹/₄" (17.5 x 17.1 cm). The Museum of Modern Art, New York.

Harry Callahan's pictures relate to his own body; for the most part he has photographed an area some 5 to 50 feet from his body (reaching from just a little beyond arm's length to across a street), over which he seems to have direct, physical control. Callahan frequently depicts leisure activities. Here we find him at midday in his bedroom, relaxing with his wife and child, with blinds drawn.

gays, and anyone else who threatened heterosexual male supremacy. In the 1950s, with the end of these crises, the threat of worldwide Communism was used to justify the continuation of such suppression. In addition, society was alarmed at the first stirrings of what would become the gay liberation movement. Gay men and women, who had been drawn from their isolation in small town America, had met other gays in the military; at the end of the war, when the services discharged all soldiers into large cities, gays stayed in the cities because they found greater anonymity there than they had in the provinces. In the United States, anti-Communists were outspoken in their condemnation of homosexuality. Communists and homosexuals were linked in Cold War ideology as twin threats to the stability of democracy. They were considered insidious threats precisely because they went unseen and eluded any system of visual control. The fear was that one's neighbor could be "red" or "queer" and yet escape detection. The anxiety of 1950s America arising from its inability to discover the symbolic concretizations of such intangibles as homosexuality and Communism was represented symbolically in the 1956 film *Invasion of the Body Snatchers*, in which an alien force imperceptibly takes over a small town.

Still from the film *Invasion of the Body Snatchers*, 1956.

Callahan's photographs present his heterosexuality as obvious and self-evident. They do so literally, attesting to his status as father and husband through the representation of his child and wife. They also do so symbolically. According to the culture of the time, homosexuality (like Communism) was associated with invisibility, heterosexuality with visibility. Through his teaching at the Institute of Design, a school founded in Chicago in 1936 by Hungarian artist and former Bauhaus master László Moholy-Nagy, Callahan was heavily influenced by "new vision" photography. This vision was highly formal, but it also served, along with Surrealism, to represent visual reality as something already coded into a representation or sign. In the formal elegance and pictorial flatness that they take from the "new vision," Callahan's photographs signify their status as photographs. They draw attention to vision, making it concrete as a process and denaturalizing it. As a result, when we see Eleanor and Barbara we see them as having been photographed, which

we take to mean having been seen – and hence visible. The visibility of their status as wife and mother and as child (and by extension the implied visibility of Callahan's status as husband and father) assuage 1950s anxiety over the invisible in society.

The highly inflected, formal quality of Callahan's photographs of Eleanor becomes apparent when they are compared to other photographs on similar themes from the same time. His pictures have their iconographic roots in the amateur photography of the camera clubs, in which Callahan himself first learned the technical and aesthetic aspects of his medium. From the mid-nineteenth century to the first decade of the twentieth century, camera clubs (along with the other institutions of amateur photography, which included periodicals and local, regional, national and international exhibitions), were hyper-aestheticized, domestic, and open to women and gay men. The early Modernism of Stieglitz, Weston, and Strand had defined a more masculinized notion of photography; and when a revitalized camera club movement emerged in the United States at the end of the Depression, it too had been masculinized. Callahan's photography was learned within camera clubs that had both men and women members, but whose attitudes towards the female body defined them, like much else in the United States at the time, as largely masculinized.

As he did on other occasions in his career, Callahan began with a subject that had great currency in camera club photography; he then broke the rules that club photography would have imposed on its treatment. Female nudes abounded in camera magazines, where "art" was invoked to justify disrobing the female model. Respectable photography magazines of the 1930s and 1940s (not those that existed only as a means of presenting pornography) suggested "girls" as appropriate subjects for amateur photography with articles such as "Posing the Girlfriend" and "Snapshots of Girls." A work by the salon photographer William Mortensen, reproduced in 1941 in *Popular Photography*, is a perfect example of the type (FIG. 65). With her arms crossed over her head, the model arches her back to display a flat stomach and uplifted breasts. Flat lighting and print manipulation change flesh into an artificial, uniform surface and the body itself into a series of idealized contours. This idealization is noted in the caption: "This Mortensen photograph bears no brand of specific time or place. Its beauty has universal appeal. Every detail which might date it is eliminated or subdued." Other excised details include pubic and underarm hair. The caption does not mention other elements that might equally date the

This Mortensen photograph bears no brand of specific time or place. Its beauty has universal appeal. Every detail which might date it is eliminated or subdued.

by
WILLIAM
MORTENSEN
•

CREATE *Lasting* INTEREST

26

65. WILLIAM MORTENSEN
(1897-1975) Untitled illustration for "Create Lasting Interest,"
Popular Photography, vol. 8, no. 3, March, 1941.

picture, such as plucked eyebrows penciled to an arch and the hard contours of painted lips.

The public encouraged the making of photographic female nudes but condemned them if they were not sufficiently "artistic". This was a problem for Callahan, who chose not to use the same means as Mortensen to achieve the required level of artistry. Callahan's pictures are, in fact, in sharp distinction to those found in camera magazines of the 1940s, in which breasts are flaunted and pubic hair concealed to satisfy the law. In choosing in many pictures to show Eleanor's pubic area rather than her breasts, Callahan daringly rejected the expectation in Western art that female sexuality should be expressed through the depiction of the breasts, and not through any overt reference to the pudenda. Eleanor's breasts or pubic area are never in view at the same time as her face; one or the other is averted. Nonetheless, even as he resisted camera club rules, refusing to use pre-existing formulas or references to classicism or mythology in order to create nudes that were honest and straightforward, Callahan kept within the clubs' dictate that only aesthetics justified nude photography. He may have refused to use mythologizing props, but he was still creating his own myth of Eleanor, often superimposing her body over images of nature.

What Callahan was doing in his photographs was not unique to America. In 1950 the French photographer Robert Doisneau made a series of pictures in Paris depicting the joys of conventional, heterosexual relationships. The series included photographs of a young couple in the Paris Metro (FIG. 66), of another couple at a café, and, in the most famous image, *Le Baiser du Trottoir (The Kiss on the Sidewalk)*, showed a couple kissing, in an embrace so intense that they seem totally unaware that they are in a public space and surrounded by passers-by. The "constructedness" of these images has come to light in recent litigation over this last image. One of the paid models for the photograph requested a royalty payment for the countless times the image had been

66. ROBERT DOISNEAU
(French, b. 1912)
Le Muguet du Métro, 1953.
Gelatin-silver print, 12¹⁄₂ x
9⁵⁄₈" (32 x 24.5 cm).

reproduced. That these pictures were staged, not found, reminds us that the sentiments they express are constructed and created, not natural or intrinsic.

At the same time that Callahan and Doisneau were making aggressively heterosexual photographs, the American artist Robert Rauschenberg and his wife, the artist Susan Weil, were making life-sized prints of their nude bodies on blueprint paper. To make these works, Rauschenberg and Weil literally went into them, placing their bodies on the paper, which was then developed through exposure to the sun. These pictures are akin to the Abstract Expressionist art of Jackson Pollock, Willem de Kooning, and others, categorized as "action painters" because they contain literal traces of the physical efforts of painting. Like the "action painters," Rauschenberg and Weil index rather than represent their bodies, which appear not as images but as traces of their having been there. But unlike Abstract Expressionist action paintings, which show the *results* of the body's *actions*, Rauschenberg and Weil in *Light Borne in Darkness* (FIG. 67) and related blueprint works of 1951 directly record the body's presence. Their works prefigure the interest in the body exhibited by performance artists of the 1960s and 1970s.

By making these indices of male and female, husband and wife, these artists created for themselves a heterosexualized position, as had Callahan in his pictures of Eleanor and Barbara. But in the mid-1950s Rauschenberg and Weil separated, and Rauschenberg became a lover and professional colleague of the artist Jasper Johns.

Minor White, who along with Callahan was one of the most important American art photographers of the 1950s, responded in a different manner to the decade's prescriptions of acceptable sexual behavior, using his photographs to explore his sexuality while at the same time intentionally obscuring his homosexuality from the prying, controlling gaze of society. While White was alive, he embedded his photographs as a whole in a discourse created around the notion of "equivalency" (a term he borrowed from Alfred Stieglitz). White described equivalency in the form of an equation – "Photography + Person Looking <—> Mental Image" – which not only defined the idea but gave it a scientific aura, in keeping with an era when science had acquired great importance. In one of his serial "equivalents," *Song Without Words*, which he put together in 1947 and continued to revise up to 1961, White created a paean to a young man. *Song Without Words* consists of eleven individual photographs of the Pacific coastline and two photographs of a young man

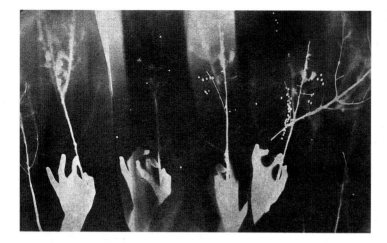

67. Robert Rauschenberg (American, b. 1925) and Susan Weil (American, b. 1930) *Light Borne in Darkness*, c. 1951. Blueprint after actual-size monoprint, 6¼ x 9¾" (15.8 x 24.7 cm). Milwaukee Art Museum, Wisconsin.

(possibly the same man in each). The content of the individual images and their dramatic sequencing strongly suggest the rise and fall of sexual tension. The images show the energy of the waves and theatrical contrasts of light and dark. The first male image is positioned at the middle of the sequence, just as the tension has reached its highest pitch; while the second male is the penultimate image, as the tension is subsiding.

White said that he wanted to make his equivalents more understandable than Stieglitz's, and he put more emphasis than Stieglitz did on the sequencing of images, which, as it grounded the individual photographs within a context, increased the precision with which the series as a whole might express his meaning. White also described how viewers should find meaning in his equivalents in *Aperture*, a journal he edited from 1952 to 1975, during which years it was a leading and often lone advocate of artistic photography. Yet the structures that White created around his photography were a gambit intended to obscure more than they revealed. He only partially wanted his meaning to be deciphered, because his photography alluded to his homosexuality. The embedding of homoeroticism within "artistic" photography was not, of course, unique to White. In the 1950s and 1960s gay men evaded the prohibition on their self-representation by using art or physical culture magazines. White did also make explicit sexual photographs of nude male bodies, often those of younger men whom he knew (FIG. 68). These pictures were neither exhibited nor published until the 1980s, by which time White had died and public attitudes towards homosexuality had changed.

68. MINOR WHITE

(American, 1908-1976) *Portland, 1940*. Minor White Archive, Art Museum, Princeton University.

Minor White's erotic picture of the male body is consistent with the conventions that eroticize the female body. The tilt of the head removes the subject's visage from the viewer's gaze, opening up the possibility of sexualizing the body. The controlled, directional light serves, with the least means possible, to suggest an interior, private space, just as it does in Callahan's *Eleanor and Barbara*.

FIVE

1960-1975: The Body, Photography, and Art in the Era of Vietnam

69. MARTHA ROSLER
(American, b. 1943)
Untitled. From *Bringing the
War Home: House Beautiful*
(1969-1971). Photomontage,
14 x 11″ (36 x 28 cm).

I n the turbulent 1960s, photograph and body took on ever greater roles in the definition of culture and art. Photography was the perfect medium for the expression of the decade's "here-and-now" spirit, and was embraced as an identifying mark of the new generation, often in a very personal form. The immediacy of television, the ever-growing availability of low-priced 35mm and Instamatic cameras, and the teaching of photography in universities, rather than in art schools, suggested to the generation of the 1960s that they make photographs of their own that would be at once records of the world around them and a means of self-expression. However, with illustrated magazines giving way almost entirely to television by the late 1960s, journalistic photography offered few jobs and a shrinking audience. Young photographers, who a generation earlier would have been lured by the ideals of mass communication, began to use the medium to create personally expressive, object-oriented works. Traditional demarcations between self-expressive "art" photography and professional photojournalism fell away; identical photographs might appear as "art" in museums and as "documents" in the daily press; and similar issues or events might be the concern of both art photographers and photojournalists.

In the 1960s the camera became a tool that promised engagement with the world. This romantic idea of photography was captured in Michelangelo Antonioni's 1966 film *Blow-Up*. That photography defaulted on this promise, in fact denying easy access to reality, was argued by the writer Susan Sontag in a series of stunning essays from 1973 and 1974 (later published as *On Photography* in 1978). But photography still seemed to document the defining events of the era, perhaps with more force than ever before; providing poignant reports of civil rights marches and demonstrations in the southern states of America, damning records of the war in Vietnam, and euphoric evocations of rock concerts and rock stars.

Even more specifically, many crucial events of the decade were defined by the human body: the American Civil Rights movement by the racial body; political assassinations by the physical body; the war in Southeast Asia by the dead and wounded bodies of soldiers and civilians; the anti-war movement by the collective body of pacifist protesters; and the unrest in May 1968 in France and throughout Europe by the bodies of students.

In the United States, the 1960s began with a new presidential administration. The Republican Dwight D. ("Ike") Eisenhower, a former World War Two general and NATO commander, was succeeded as president by the Democrat John Kennedy. The United States was now governed by a new generation of young, good-looking, and intelligent men. Some of these new leaders

appear in Arnold Newman's *President Kennedy and New Frontier Advisors at the White House* (FIG. 70), which was published in 1965 in *Esquire*, a leading glossy men's magazine. On one level, this picture seems merely to be a neutral presentation of faces and bodies, with no apparent political agenda. On another level, however, carried on the bodies of the group members are characteristics such as gender, race, able-bodiedness, and economic status, that do convey a specific ideology. We see from the picture that they are male, white, healthy, and well-dressed, qualities from which their power seems to accrue. Also evident is the absence from the scene of people who are female, black, handicapped, elderly, or members of the working and middle classes. The group is defined in part precisely by these exclusions.

The Kennedy administration ended prematurely and tragically in Dallas, Texas, with the president's assassination on November 22, 1963. The horrors of this event were recorded in photographs of the stoic young widow in a blood-soaked skirt, and in the frames of Abraham Zapruder's film which capture the assassination itself. The repeated resurfacing of the latter in the context of debates about the identity of the assassin reminds us that the belief that photography offers incontrovertible evidence, which arose in the nineteenth century, still operates today. But the failure of the film, as an "objective" document, to resolve the debate also reminds us of photography's ambiguity and irresolution. Less ambiguous (because the killer is pictured) is another photograph that records a defining event of the 1960s in terms of the body: Robert Jackson's picture of Jack Ruby shooting Lee Harvey Oswald, Kennedy's accused assassin, in the basement of a Dallas police station on November 24, 1963. Other critical assaults on bodies recorded by photography were the killings of Martin Luther King, Jr., the civil rights leader, of Robert Kennedy, a candidate for the Democratic presidential nomination and brother of the slain president, and of James Meredith, a civil rights marcher.

The war in Vietnam was defined in the United States by the body bag and the body count. The arrival of each body bag marked a political and tactical setback, but more importantly grief and loss for the family and friends of the dead soldier. The body count became a way of keeping score, of going through villages and jungles where battles had taken place, counting the dead from each side and reporting the results to the high command in Washington. There figures were altered to reflect political exigencies, to suggest that the war was going better for the United States than, in fact, it was.

Earlier in the twentieth century governments had learnt to limit the photographic coverage of wars, but during the Vietnam war, the United States government was unable to control coverage of the conflict by photojournalists. The pictures that emerged from the war gave momentum to already existing anti-war sentiments. A famous press photograph, made by Eddie Adams in South Vietnam in 1968, showed the summary execution of a Vietcong suspect by the National Police Chief of South Vietnam (FIG. 71). The photograph graphically documented an event that symbolised the moral failure of the regime the United States supported in South Vietnam. Other photographs showing the destruction of human bodies also turned American public opinion against the war. These included Huynh Cong (Nick) Ut's horrifying image of a naked Vietnamese girl running down a road screaming, trying to escape destruction by napalm. The girl's nude body appears as something vital, essential to continued human life on earth. The United States Army photographer Rob Haeberle's pictures of the My Lai massacre of women and children averred the occurrence of an event many politicians, journalists, and members of the public doubted had happened, just as Lee Miller's photographs had helped attest to the reality of the Holocaust. Color photographs made by Larry Burrows, a British photojournalist killed in battle in Vietnam in 1971, remind us again of the extent to which the Vietnam war was centered on the body, and of the extreme viciousness of guerrilla warfare, which aimed less to capture or kill than to maim the bodies of the opposing forces (FIG. 72).

71. EDDIE ADAMS
(b. 1933) *Brigadier General Nguyen Ngoc Loan, National Police Chief of South Vietnam, executing the suspected leader of a Vietcong commando unit, Saigon, Vietnam, February 1, 1968.*

Eddie Adams's powerful image is one of the many photographs of the 1960s that couched international political and cultural events in terms of the human body.

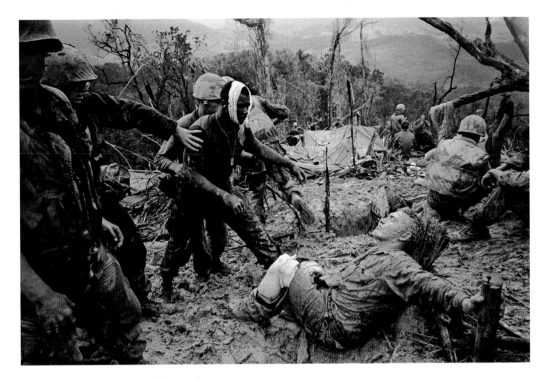

Political Turmoil and Social Upheaval

72. Larry Burrows
(British, 1926-1971)
*At a First-Aid Center during
Operation Prairie,* 1966.
Dye-transfer print, 15^1/$_4$ x
23^1/$_2$″ (39.1 x 59.7 cm).
Spencer Museum of Art,
University of Kansas.

The social upheavals in the United States, which accompanied the war in Southeast Asia, likewise centered on and in many ways redefined the body. Borrowing from the sit-ins of the civil rights movement earlier in the decade, members of the anti-war movement fought against military involvement abroad in very physical, although non-violent, ways. Using their bodies, they attempted to block entrances to military bases and federal courthouses where draft boards and military induction centers operated, obstructed traffic in Washington to close down the federal government and, once, encircled (and attempted to levitate!) the Pentagon. The sad results of one such protest appears in a photograph by university student John filo entitled *Kent State University, Kent, Ohio* (May 4, 1970). It shows a teenager leaning over one of the four student protesters shot and killed by members of the National Guard, called in to quell a demonstration.

Many of the cultural ramifications of the war impinged on the body as well. To show their disrespect for the dominant values of society men of the younger generation grew their hair and beards, while women wore loose-fitting clothes and went bra-less. The counter-culture that emerged was one of action, not of reflection or contemplation. The return to the land, to

73. THOMAS WEIR
(American, b. 1935)
*Renée Oracle 1968-1970
(Nude lying on back in
landscape)*, 1968.
Cyanotype, 13 x 13" (33 x
33 cm). Spencer Museum of
Art, University of Kansas.

farming and homesteading, meant not just an abandonment of urban, mercantile life but also an embrace of hard, physical labor. The body culture was also reflected in contemporary folk and rock music and in the prevalence of drug use. Music, often carrying a social message, inspired frantic, wild dancing. Marijuana and psychedelic hallucinogens altered and heightened awareness of the body. By sharp contrast to the repressiveness of the 1950s, the body culture of the 1960s produced an atmosphere of sexual freedom, in part due to the easy availability of oral contraceptives. The social agenda of the counter-culture of the late 1960s and early 1970s – "sex and drugs and rock-n-roll" – is

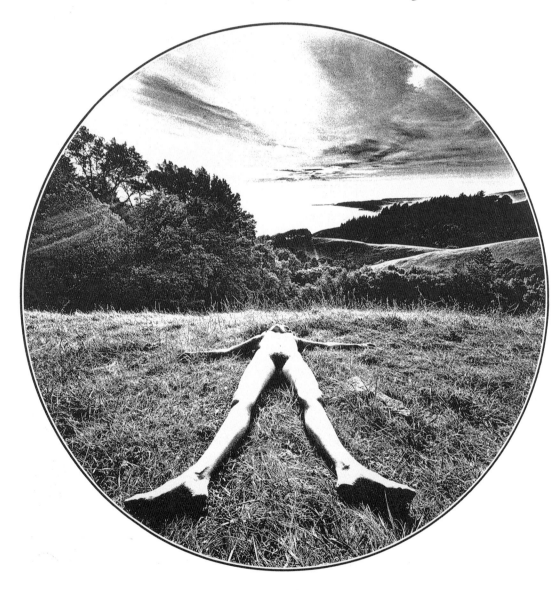

summarized in Thomas Weir's 1968 cyanotype nude *Renée Oracle* (FIG. 73). Weir's female figure is lying in a field of grass, unclothed. The camera, looking up towards her exposed pubic area, suggests masculine desire. Weir, who also made photographs for the jackets of LP records of Janis Joplin and The Grateful Dead, used the cyanotype process (similar to the blue-prints used by architects and engineers) to reduce the natural range of colors to a few abnormally bright, intense hues, suggesting the visual hypersensitivity of a drug-induced euphoria. In using cyanotype, Weir was reviving an older technique, consistent with the counterculture's turning away from modern technologies in favor of the handmade artefacts of pre- and early industrial society. Similar challenges to modernity, and emphases on handwork, had been mounted by members of the English Arts and Crafts movement and by turn-of-the-century Symbolists. It is ironic that Weir's photograph of the female body as sexually available should have these reverberations of Victorian England.

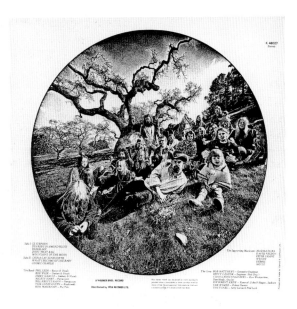

The Grateful Dead, *Aoxomoxoa,* 1969. Back cover photo by Thomas Weir.

74. JEAN-FRANÇOIS BAURET *First Telltale Signs that the French sun may be sinking on the French Empire as well – Frank Protopas.* From *Esquire,* January 1969. Silver print, $10^{1}/_{2}$ x $8^{1}/_{4}$" (26.9 x 21 cm). Spencer Museum of Art, University of Kansas.

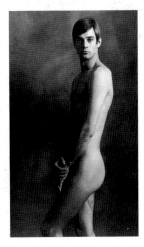

The widespread cultural ramifications of the student strikes of May 1968 are represented allegorically rather than literally in a photograph from that year made by Jean-François Bauret as part of an advertising campaign for men's briefs (FIG. 74). When the advert appeared in *Le nouvel observateur*, it was the first time a prominent French magazine had run an advert with a nude male model. In choosing to use a male figure, Bauret upsets the cultural assumption (current since at least 1848) that men should not be used to represent ideals that differ significantly from their own subjectivity. Showing a male nude, as opposed to the culturally dominate female, returns this image to an earlier era, that of the post-Revolutionary Neo-classical art of David and Ingres.

Ray Metzker, an American photographer who had studied with Harry Callahan, also created allegories around the human body that reflected changes in society. Taking from Callahan a formalist interest in what happens by chance in the course of exposing a roll of film, Metzker made photographs in the late 1960s in which he printed two adjoining negatives as a single

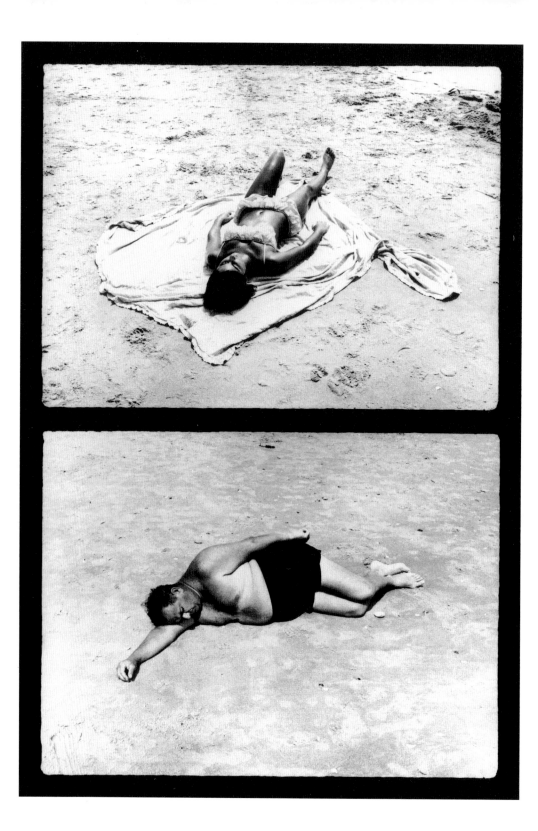

1960-1975: The Body, Photography, and Art in the Era of Vietnam

image. One of these, *Couplets: Atlantic City* (FIG. 75), juxtaposes two shots made on the beach at Atlantic City, New Jersey. The surrounding black frame flattens the two images into a single plane, so that the bodies seem to float, hovering like clouds above the earth. By printing the two negatives together, Metzker produces an image that defies our expectations that the body will be oriented to the ground and that a normal gravitational field will exert itself. In perhaps too literal a way, the man in the lower frame seems to have "gotten high." More symbolically, the body refuses to obey the rules (in this case of gravity and perspective), and acts according to its own wishes and desires.

While the counter-culture of the late 1960s may appear most clearly in works by Weir, Bauret, and Metzker, changes in attitudes towards the body were also explored by photography that used more conventional techniques. A number of photographers working in the late 1960s adapted the methods of photojournalism and reportage to more personal expression. Abandoning the large-format (4 x 5 or 8 x 10 inches) cameras and tripods of earlier eras, they used small cameras which they could wield freely as extensions of their bodies and supplements to their eyes. At an earlier time these photographers would have been photojournalists, but television had made *Life* and other traditional illustrated magazines redundant. As photojournalism became a less viable way to make a living, so it gained some of the non-utilitarian status of art. The best of what would have been photojournalism, albeit of a very subjective type, no longer appeared on the pages of magazines but in museums and artists' books.

The work of three such photographers – Lee Friedlander, Diane Arbus, and Garry Winogrand - was exhibited in 1967 in the show *New Documents* at the Museum of Modern Art in New York. John Szarkowski, the organizer of the exhibition, noted that what held the work of the three photographers together were "the belief that the commonplace is really worth looking at, and the courage to look at it with a minimum of theorizing."

Winogrand and Friedlander were called "street photographers." They abandoned the idyllic space of Weston's and Adams's landscapes, and in search of subjects wandered urban streets. Street photographers raised the status of looking, catching off-hand moments without first checking through the viewfinder or even aligning the camera with the horizontal. They practiced an art of the body and not of the mind, and their goal was to "capture" the scene in the very moment they saw it, without contemplation.

75. Ray Metzker (American, b. 1931) *Couplets: Atlantic City*, 1968. Silver print, 9 x 6¼" (22.8 x 15.8 cm). Spencer Museum of Art, University of Kansas.

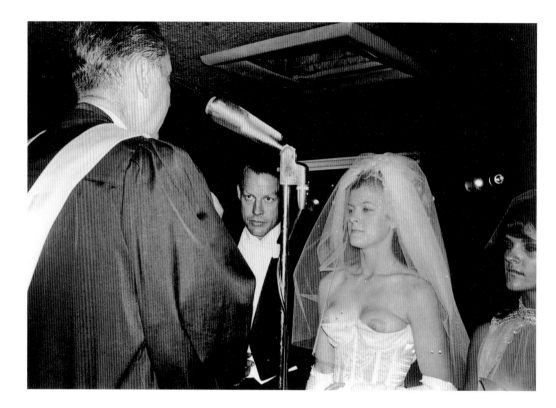

76. LEE FRIEDLANDER
(American, b. 1934)
*Topless Wedding in Los
Angeles*, 1967. From *Esquire*,
December 1967. Silver print,
8¼ x 12⅜" (21 x 31.5 cm).
Spencer Museum of Art,
University of Kansas.

It was, in fact, just this "here-and-now" quality that legit-imized street photography as art within the aesthetics of the 1960s, which held direct, bodily experience as paramount. Street photography shared with Minimalism, Pop art, Happenings, and such experimental artists as the fluxus group not only immedi-acy, but also a disregard for history, tradition, and anything else that could not be seen or felt. By emphasizing direct experience, artists of the 1960s rejected Abstract Expressionism's concern with non-literal, existential values. Furthermore, by choosing immediacy over history and tradition, these artists also rejected the rationalist arguments used by the American government to justify involvement in Vietnam.

In his photographs Friedlander watches people, himself included, in various public and private spaces. But, unlike pho-tojournalists of the previous generation, he uses the formal lan-guage of photography, including reflections, shadows, and the careful structuring of pictorial elements, to distance himself from his subjects. In *Topless Wedding in Los Angeles* (FIG. 76), which appeared in *Esquire* magazine in 1967, Friedlander looks with bemused detachment at a ceremony in which conventional rules of decorum are being flouted. Friedlander's formal distance

makes this a surprisingly ungendered picture, given its content; as was suggested in the catalogue for an exhibition by *New Document* photographers, Friedlander looks with sympathy and even affection at "the imperfections and the frailties of society," finding there "wonder and fascination and value" which is "no less precious for being irrational."

For Arbus, the commonplace was very often the body itself. Arbus found ordinary and exotic subjects whose special qualities and quirks were manifest in the body, so that for her it was not a case of making pictures whose meaning could only be inferred, but rather of finding subjects that revealed themselves immediately and literally to her camera. Some of the bodies Arbus photographed were unconventional – those of actual circus freaks such as giants and midgets, and of nudists, transvestites, overweight teenagers, and people with learning difficulties (FIG. 77). But to Arbus's camera even the bodies of young suburbanites seemed strange.

Arbus's photographs are less spontaneous than those of Friedlander and Winogrand, who used 35mm cameras to produce long, narrow negatives that seemed symbolic of the dynamic physical action of shooting with such a camera. Arbus made her photographs with a camera that produced negatives

77. DIANE ARBUS
(American, 1923-1971)
A Family One Evening in a Nudist Camp, 1965. Gelatin-silver print.

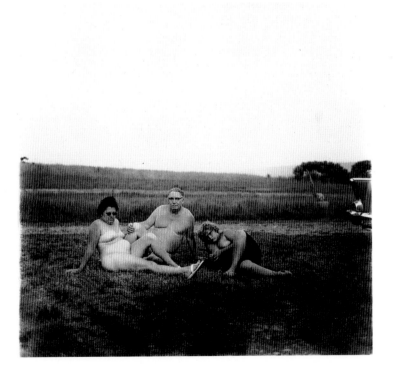

78. JILL KREMENTZ
(American, b. 1940)
Party at the Electric Circus,
1967. From *Esquire,*
December 1967. Silver print,
9 x 13½" (22.7 x 34.4 cm).
Spencer Museum of Art,
University of Kansas.

2¼ inches square. This format was more static and classical than that of 35mm photography. Arbus's photographs are similar to early tintype portraits, to the works of Francis Frith and other nineteenth-century expeditionary photographers, and to the taxonomic portraits of August Sander. Arbus chose to present her sitters head-on, centered in the frame. They appeared to be subjected to scientific scrutiny. But her subjects are more ordinary, more accessible, despite their obvious deviations from social norms.

Some photographers documented events that were explicitly of the moment. Jill Krementz's *Party at the Electric Circus* (FIG. 78) shows the kind of public liberation of the body that took place during this period. A very similar hedonistic spirit, but in a totally different environment, is seen in Andy Warhol's *The Performance Group – Dionysus in '69* (FIG. 79), a photograph that records a performance of an updated version of the Dionysus myth. As in Krementz's photograph, nudity abounds and Dionysian pleasures and pains are played out reflecting the new permissiveness of society.

Larry Clark's photographs, like Krementz's and Warhol's, exploit the potential of nudity to shock the old and unify the young. Clark explored aspects of bodies at the fringes of society in two books of photographs. In *Tulsa* (1971), he photographed a group of young drug addicts, documenting their use of needles and guns, and the deaths that resulted. In *Teenage Lust* (FIG. 80),

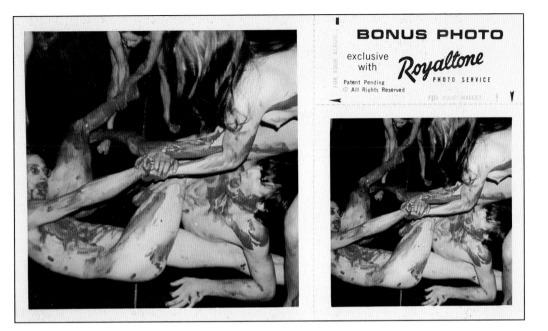

Above 79. ANDY WARHOL
(American, 1928-1987) *The Performance
Group – Dionysus in '69*, 1969. From *Esquire*,
May 1969. Color print, 3¹/₂ x 6″ (8.8 x 15.1
cm). Spencer Museum of Art, University of
Kansas.

80. LARRY CLARK
(American, b. 1943) *Oklahoma City*, 1975.
From *Teenage Lust*. Gelatin-silver print.

he photographed as an outsider the sexual activities of teenagers. In some ways Clark, in this latter project, was no different from Lewis Carroll and other nineteenth-century photographers who claimed to document objectively the sexuality of their subjects, but seem instead to project their own sexual fantasies onto their young sitters. The question remains: to what extent is Clark a voyeur, titillating himself and his viewers, and to what extent is he providing insight into the sexual activities of American teenagers of the 1970s?

The government's prosecution of an unpopular war lessened respect for the government and for the established order in general. The social turmoil at home, away from the war itself, manifested itself both in the exploitation of newly won liberties and in the exploration of life's darker sides. The bodily carnage abroad had a very specific impact on the way the living body

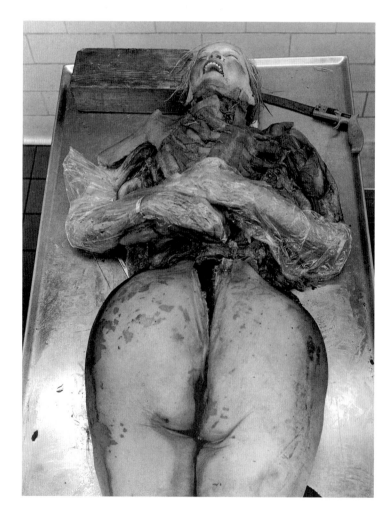

81. JEROME LIEBLING (American, b. 1924) *Cadaver, New York City*, 1973. Gelatin-silver print.

A cadaver is more than simply a dead body; it is an embalmed body used for medical studies, able to last many hours in the laboratory without putrefying. For Jerome Liebling, cadavers provided especially gruesome bodily forms, rearranged with a flexibility not unlike the *poupée* made by the photographer Hans Bellmer.

was viewed at home, as has already been noted. It also led some photographers to explore the bodies of the dead and dying. Richard Avedon, better known for his fashion work, photographed the deteriorating body and gradual death of his father from cancer. The body is central to the work of Jerome Liebling who early in his career produced a series of photographs of the slaughter of cattle for the meat-packing industry, and more recently photographed dead bodies in New York City morgues (FIG. 81). His cadavers are especially gruesome; they are not the bodies of the young or the healthy or even the recently dead. Rather, they seem to be the unclaimed bodies of the very old and the very poor, people who lived and died at the fringes of society, without the care of family or friends.

The body was also taking on a new importance in art in general. In the work of the Abstract Expressionists of the late 1940s and early 1950s, especially those classified as "action painters," the body left behind marks of its actions and gestures in the form of exaggerated brushwork. In the art of the period that followed, the body was present in a much more literal, concrete way. The Pop art of Roy Lichtenstein, James Rosenquist, Andy Warhol, and Tom Wesselman appropriated literal renderings of the body from comics, advertising, and news photographs, where they had already been mediated – that is to say, subjected to controlling ideological forces. Art of the early 1960s questioned the art object itself, and often conflated performance and conceptual art with more traditional subjects. Even Minimalist art, which can seem so impersonal, sometimes involved the human body in very visceral ways. Robert Morris's *I-Box*, of 1962, was a small, shallow wooden box, with a door cut into it in the shape of the letter *I*. The *I-Box* invited viewers' active, physical participation, requiring them to open the box, which then revealed another body: that of the artist, in a full-length, frontal nude photograph.

The Feminist Politics of Performance and Body Art

After Vietnam, the United States went through a real identity crisis, and experienced a period of self-doubt. Artists moved away from the commercial, public imagery found in the art of the 1960s (in Pop art, for example) to a much more subjective, inward-looking art. Also in the 1970s, works of art are typically less refined than the pristine, carefully finished art of the 1960s; certainly this relates to the influence of conceptual art, where the

idea took precedence and where the finished art object was de-emphasized.

The importance of the women's movement in the 1970s to art of that period (and later) cannot be underestimated. Despite social movements and the sexual liberation of the 1960s, the role of women and their objectification in art remained unchanged, even at the very end of that decade (a fact to which Weir's photograph attests). It was only in the 1970s, partially under the impetus of the civil rights and anti-war movements, that a women's movement emerged. For the first time, increasingly large numbers of women came to the fore in the art world, and were influential to the kind of work produced by men both in terms of content and media. Women artists sought out and pioneered new media, such as performance, body, and video art which, unlike traditional media (painting, sculpture), were not associated with the male-dominated artistic tradition. By using their own bodies as medium and subject, women artists sought to gain literal and figurative control over their bodies, exploring directly (even viscerally) the uniquely female gendered experience which they felt artists had previously ignored. Spurred on by innovations made by women, some male artists also began to consider the roles their own (male) bodies played in the production of social values.

The relationship of photography to body and performance art is ambiguous. For the most part, performances were intended to be experienced live and in real time, however photography played a key role in documenting these events. These photographs have with time come to stand in for the performances themselves. Moreover, the fact that performances were documented through as ordinary and cheap a medium as photography, and through photographs that seemed to be made in an off-hand, casual way, strengthened the argument that performance art eroded the hierarchies traditionally separating art from life. Such is the case with a photograph documenting Carolee Schneemann's 1975 performance, *Interior Scroll* (FIG. 82). The photograph, like the performance itself, represents aspects of the female body that social convention has rendered invisible and unspeakable. In pulling a scroll from her vagina, Schneemann aggressively asserts her gender in a way consistent with the feminism of the 1970s.

Hannah Wilke used her own body to produce photographs that, like the performance art of Schneemann, centered on the politics of the female body. In photographs made from the early 1970s until her death in 1993, she was concerned with the female

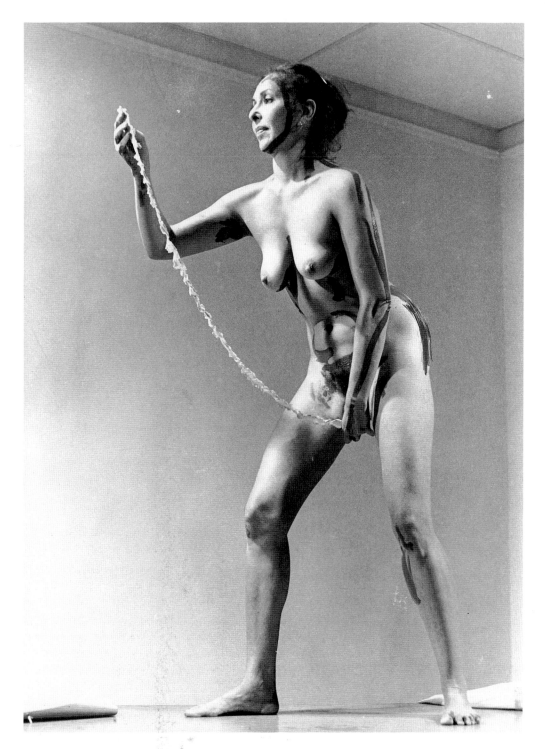

82. CAROLEE SCHNEEMANN
(American, b. 1939) *Interior Scroll*, 1975. Photographer's collection.

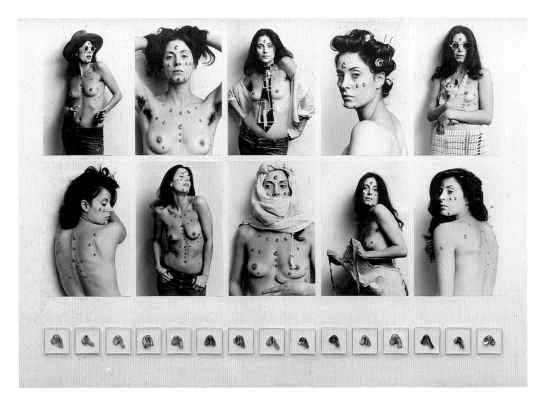

83. HANNAH WILKE
(American 1940-1993) *S.O.S.
Stratification Object Series*,
1974-1982. From a series
originally made for S.O.S.
Mastication Box and used in
an exhibition performance at
The ClockTower, New York,
1 January 1975. 10 gelatin-
silver prints with 15 chewing-
gum sculptures in plexiglass
cases mounted on ragboard,
40¹/₂ x 58" framed (102.8 x
147.3 cm). Ronald Feldman
Fine Arts, New York.

body's representation in the media and in art. Wilke's work appeared most frequently as lithographed posters or in books and magazines. It parodies the narcissism conventionally attributed to women, exaggerating it as a form of masquerade.

In her early work Wilke combined a form of body and performance art when she photographed her body after covering it with small pieces of chewed chewing-gum, folded to suggest female genitalia (FIG. 83). This process gave physical and visual form to the psychological fetishization of the female body under the male gaze. Wilke used the chewing-gum shapes strategically: as a masquerade that allowed her to escape male scrutiny, and as a psychological means to undo the repression upon which fetishization depends. Similarly, in the later 1970s and early 1980s, Wilke made photographs of her own body, frequently nude, which she then captioned to challenge the viewer to rethink the effects of conventionalized representation on both the female body and on viewers of both sexes. Wilke's final project was to photograph her body during the two years of lymphomatic cancer that killed her.

A similarly tactile sense of women's bodies is seen in the body art, site-specific earthworks, and performance art of Ana

Mendieta. Mendieta uses the traditions of *santeria* (a cultural mix of the religions of Africa and America, widespread in her native Cuba) as a means of connecting her body with basic natural substances such as blood and earth. In the *Silueta* series (FIG. 84), executed in Mexico and Iowa between 1973 and 1980, she photographed her body in natural settings, covered with natural materials (mud, blood, and wild flowers); in some works in the series she omitted the presence of her own body and created replicas of its form with grass, charred wood, or earth (FIG. 84). These works are ephemeral and suggest, in their dissolution of physical and temporal boundaries, considerations of death and spirituality.

The work of Schneeman, Wilke, and Mendieta suggests a primal relationship of the body and elements that might seem germane only to women. However, there were also male artists of the 1970s who explored the relationship of their bodies to natural elements. Dennis Oppenheim made his body the passive receptor of the sun's rays, which outlined on his flesh a book held on his chest (FIG. 85). Dieter Appelt covered his body in mud, which when dry immobilized him, thus destroying one aspect of the power that defined it as male (FIG. 1).

84. ANA MENDIETA
(Cuban, active United States 1948-1985)
Untitled. From the series *Silueta (Silhouette)*, 1978. Gelatin-silver print, 11¼ x 14″ (28.5 x 35.5 cm). Spencer Museum of Art, University of Kansas.

86. KATHARINA SIEVERDING
(Czechoslovakian, b. 1944) *Die Sonne un
mitternacht schauen (To look at the sun at
midnight)*, 1988. Five color photographs, acrylic,
steel, 9' x 21'3" (2.7 x 6.4 m) overall.

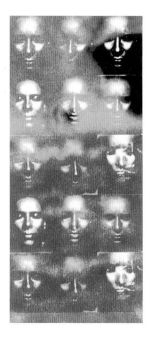

85. DENNIS OPPENHEIM
(American, b. 1938)
*Reading Position for Second
Degree Burn, Stages 1 and 2,*
1970. 7' 1" x 5' (2.1 x 1.5 m).

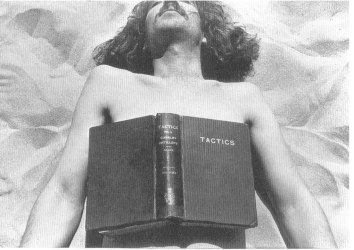

READING POSITION FOR SECOND DEGREE BURN.
Stage I, Stage II. Book, skin, solar energy.
Exposure time: 5 hours. Jones Beach, 1970.

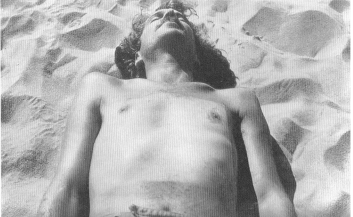

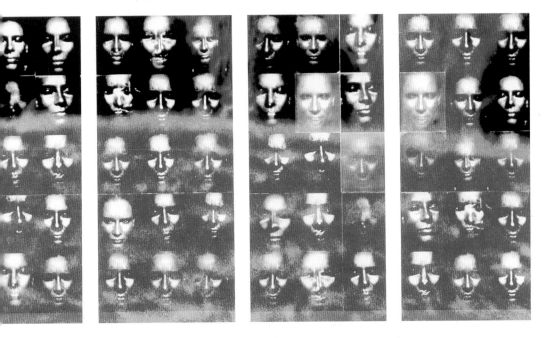

Katherine Sieverding, like Wilke, parodied narcissism as she explored ways to represent her own body, yet evade the male gaze. In work that she began in the early 1970s, she photographed her own heavily made-up face, producing both color and black-and-white photographs in which the contrasting tones of the pictures emphasize the artificial, mask-like quality cosmetics give to the face (FIG. 86).

Other feminist photography of the period is concerned with questions of gender, sexual orientation, and race, the reconsideration of photography itself, and the association of the body with work, and with other social affairs. Martha Rosler explores the politics of representing the body in works such as the series *Bringing the War Home: House Beautiful*, from 1969-1971 (FIG. 69). In this she drew attention to two arenas of resistance in which representation is integrally tied to issues of power – the anti-war movement and feminism – by collaging images of the war in Vietnam over pictures of women taken from cosmetics advertisements. Social issues remained central to Rosler's later works as well. In *The Bowery: in two inadequate descriptive systems* of c. 1981, Rosler explores homelessness and public drunkenness in the area of the Lower East Side of Manhattan known as the Bowery. She is not concerned with documenting homelessness or alcoholism; rather, she is interested in how words and images define reality as "social problems." She undermines the pose of objectivity in "find-a-bum" photography (the descen-

dant of the Depression photography of Lange and others), in which photographs confirm suspected realities rather than analyzing them and the power relationships that create them. By juxtaposing words and images, Rosler suggests that visual description is as subjective as the verbal.

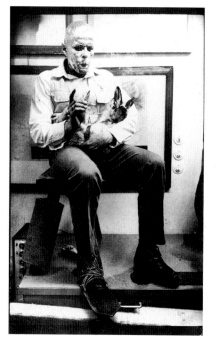

87. JOSEPH BEUYS
(German, 1921-1986)
How to Explain Pictures to a Dead Hare, 1965-1970.
Photograph by Ute Klophaus.

Photography also played a central role in the 1970s performance art of the German artist Joseph Beuys. Beuys realized early on that actual performances would be viewed by a very limited audience, which was at odds with his desire that art and creative actions be integrated with life itself. He always made sure that a photographer was present at his performances, recording and documenting his actions, and in order to reach a wider audience, he expanded the traditional idea of the limited edition in graphic art to produce inexpensive editions of a wide variety of objects – including, but not limited to, photographs – related to his performances (FIG. 87). Recognizing the centrality of himself and his ideas to his performances, Beuys would affix his own signature to photographs of them, even though the photographs had been made by someone else. For Beuys, the making of the photographic record was an important part of the performance itself.

It was a small step from photographing actual, live performances to staging performances exclusively to be photographed, with no audience. The American artist Robert Cumming photographed *tableaux* that seem to be excerpts from longer performances. In *Leaning Structures* (FIG. 88), Cumming functions not only as a conceptual artist, but also as a kind of engineer, who realigns and fixes the body. He jokes with photography, acknowledging that this is a set-up. The fact that viewers recognize the staging that made it possible is part of the work itself. He also keeps in the finished piece its low-budget origins, something he shares with other early performance artists. The work does not try to hide the efforts that went into its making, but (this is especially true of *Leaning Structures*) seeks to reveal its origins and deconstruct all illusionism.

Duane Michals also staged scenes exclusively for the camera. Unlike *Leaning Structures*, which only implies that the performance continued beyond the photographic exposure, Michals's works constitute series of photographs that establish extended narratives (FIG. 89). As serial narratives, these works resist the Modernist demand that art be precious and autonomous, and the

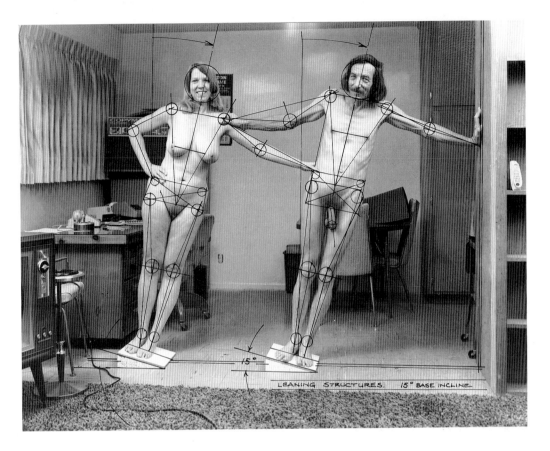

LEANING STRUCTURES. 15° BASE INCLINE.

use of one picture next to another in the series reminds us that photographs are easily and cheaply produced.

Another kind of performance takes place in the photography of the British artist Richard Long (FIG. 2). Long suggests his body in photographs where it is in fact not visible; and he does so by showing the results of programs of action he had set for it in long walks in the countryside. Long's photographs frequently show only a single scene from a walk and are captioned with information that describes with scientific coolness its route and length. In this way his walks become meditations on the inter-relatedness of time and distance and this sense of duration, the time necessary for covering a given distance, links Long's work to the body. Long's pieces in which he performs actions as he walks, such as moving rocks onto his path at regular intervals, comment upon the impact the human body has had on the land. As they are labeled with the time of the walk's duration, Long's works thus include the actualized potential of the human body for movement. A "three days' walk" is a real, kinesthetic mea-sure, one that we can experience or estimate. His photography is

88. ROBERT CUMMING
(American, b. 1943)
Leaning Structures, 1975.
Gelatin-silver print.

1960-1975: The Body, Photography, and Art in the Era of Vietnam

89. DUANE MICHALS
(American, b. 1932)
Plate 4 from the
7-print series *The
Fallen Angel*,
published in 1968.

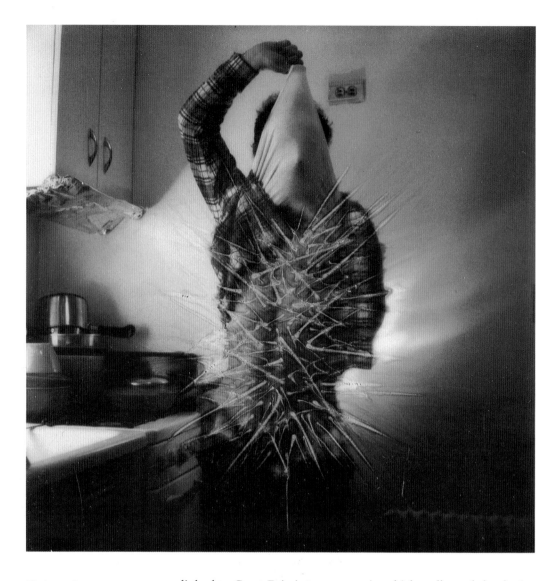

90. Lucas Samaras
(American, b. Greece, 1936)
*Photo-Transformation,
6/13/74*. Color instant print
(manipulated) 3¹/₈ x 3¹/₈ "
(7.9 x 7.9 cm) The Museum
of Modern Art, New York.

linked to Great Britain, a country in which walks and the depiction of landscape are part of the romantic tradition, and a country small enough to seem to exist, even at the end of the twentieth century, on a human, bodily scale. There is also a suggestion in his work of social class − of persons comfortable in the countryside, with access to it and the time and the money to explore it.

Some of the photography derived from performance art anticipated the feminist notion of the masquerade. Lucas Samaras and Arnulf Rainer, like Egon Schiele earlier in the century, perform for the camera and use it to enact a temporary self. In his *Photo-Transformations* of the mid-1970s, Samaras photographed himself and others with Polaroid sx-70 film, which he

manipulates with pressure and heat to alter shapes and colors and produce anti-naturalistic results (FIG. 90). Samaras's *Photo-Transformations* erase the art/life dichotomy; they are shot in his small New York City apartment, not in a studio, and the details of the photographer's private life encroach upon his art. The set-up of the photographs is simple: one imagines a camera on a basic tripod, only a few feet away from the subject. Despite their manipulation, Samaras's photographs are simple compositions. In this regard they hark back to the earliest photographic portraits and to photographs for police surveillance. Arnulf Rainer, an Austrian artist, does something similar in his *Two Flames (Body Language)* (FIG. 91). He manipulates his photographs both to erase and erode claims to "documentary" truthfulness. His first evasion of the camera's eye is to act in front of it, rather than pretend (as we do in the making of family snapshots) that he is being natural before the camera. His second evasion is to mark the surface of the printed photograph, thus transgressing Mod-

91. ARNULF RAINER (Austrian, b. 1929) *Two Flames (Body Language)*, 1973. Oil on gelatin-silver print. Tate Gallery, London.

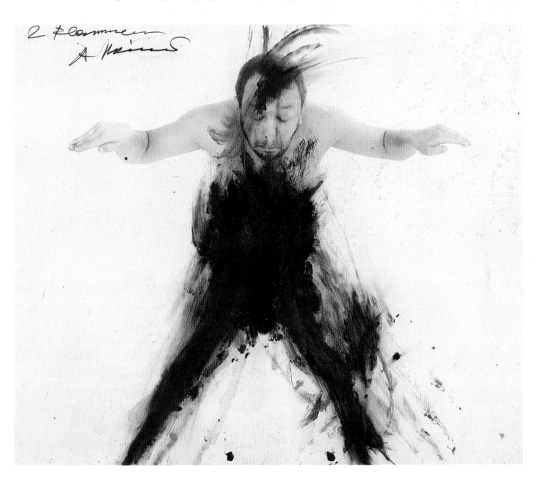

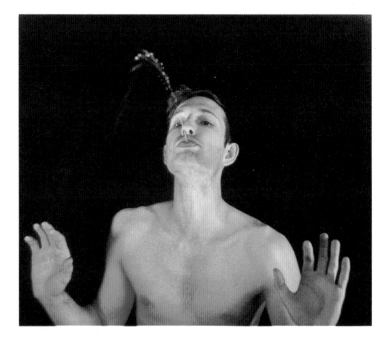

92. BRUCE NAUMAN
(American, b. 1941)
Self-Portrait as a Fountain,
1966-1967. Color-coupler
print, 19³/₄ x 22³/₄" (50.1 x
57.7 cm). Leo Castelli
Gallery, New York.

ernist tenets of the separation of art and photography, and also
defacing the glossy surface that early twentieth-century Mod-
ernists, like Weston and Stieglitz, so admired.

The works of Beuys, Cumming, Michals, Long, Samaras,
and Rainer may not address masculinity with the same self-con-
sciousness with which *Interior Scroll* addresses femininity, but
they are still gendered. The expressiveness of Samaras and
Rainer, the pseudo-science of Cumming, the authorial voice of
Michals all suggest conventionalized notions of male mastery,
while Long's walking pieces evoke conventional masculine qual-
ities of physicality, exploration, quantification, and conquest.
Other male artists have worked more self-consciously in the area
where performance art, photography, and the gendered body
overlap. Vito Acconci, Bruce Nauman, and Jürgen Klauke per-
formed for the camera, manipulating not the photograph, as
Samaras and Rainer did, but their actual bodies. Acconci, in
Conversion 2, of 1971, hides his penis between his legs. Nauman,
in *Self-Portrait as a Fountain* (FIG. 92), spews liquid from his
mouth, making his body refer to one of the traditional motifs of
sculpture as well as to one of the major monuments of early
Modernism, Marcel Duchamp's *Fountain* (1917), which was an
ordinary urinal signed and placed within an art gallery. At the
same time that Nauman's body is elevated as a whole to the sta-
tus of art, it is also demeaned. Lips, teeth, and tongue are

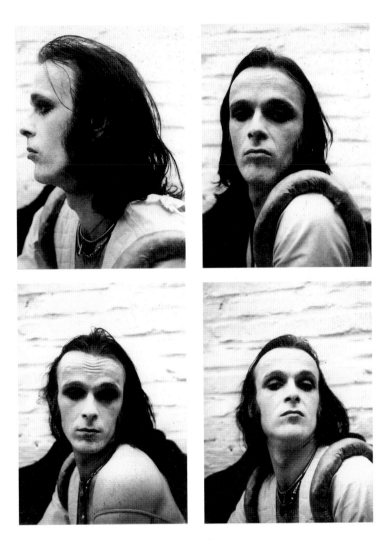

93. Jurgen Klauke
(German, b. 1934).
From the series
Physiognomien (1972-1973).
24 x 18″ (60.9 x 45.7 cm).

removed from the production of speech, instead being made to resemble orifices used to eliminate bodily waste. In the action of spewing forth, Nauman enacts other male activities, including urination and ejaculation. Klauke, in photographs from 1972 and 1973, dressed as a woman but left his hairy chest visible (FIG. 93), questioning conventional definitions of gender and masculinity. Rather than make pictures in which he could "pass" as a woman, Klauke included signs that marked him as masculine; in this way he explored the representational and psychological spaces at the intersection of male and female gender.

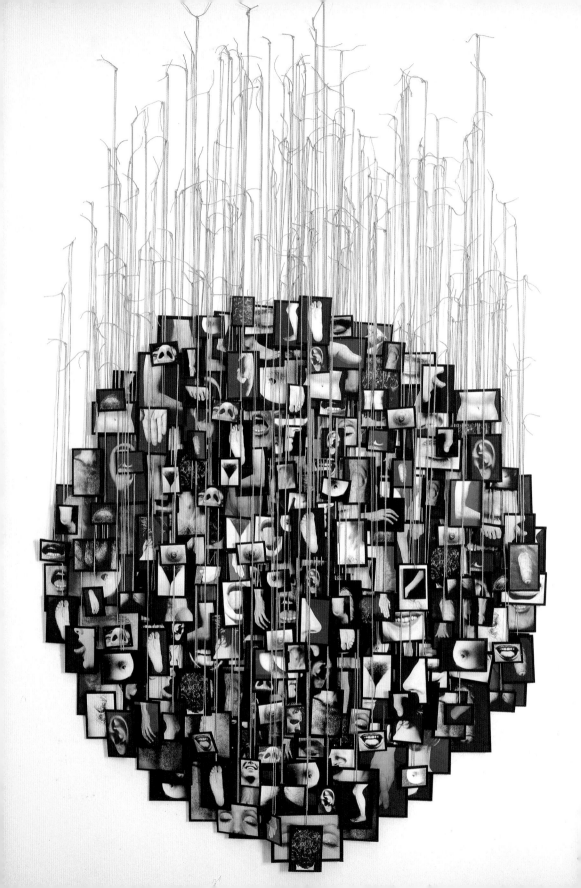

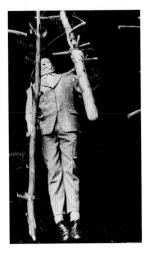

Photography Since 1975: Gender, Politics, and the Postmodern Body

During the 1920s and 1930s Modernism denied that photographers were involved with what they photographed. It established them as impartial observers, recording what lay before them with a passive eye. Formalist Modernists, like Stieglitz and Weston, kept their distance by presenting pristine abstractions, drawn from reality but independent of the visible world. They photographed seemingly without judgment and with no involvement in their subjects.

In the 1980s and 1990s a number of changes occurred in the way that photographers related to their medium and to the world. The new relationships that emerged have been grouped under the term postmodernism, suggesting that they not only follow Modernism, but also supersede it. In the United States, the politics of consensus, which had arisen in the 1950s during the Cold War, and which began to erode during the era of the Vietnam war, gave way in the 1980s to a postmodernist, multicultural perspective. As the basis for art and criticism, postmodernism has deemed aspects of formal and realist modern styles – purity, objectivity, and truthfulness – that had seemed to be essential, and external to questions of style, as being instead rhetorical devices within and subject to artistic styles.

Rather than a style, postmodernism presented photographers with strategic options. One has been to continue to use the highly purified formalist language of Modernism, but to use it more self-consciously, exploring depictions of the body, for

example, through contemporary social, economic, and political discourse. As a consequence, postmodern photographers break into taboo subjects, representing, for example, the sexuality of children and adolescents (Sally Mann) and gay men (Robert Mapplethorpe). A second postmodern strategy is to exploit and embrace earlier styles, such as Pictorialism, that Modernist photographers, critics, and historians had condemned as artificial, set-up, affected, aesthetic, even fraudulent. Postmodernists use these once-abused styles to make photography whose artifice is the very first statement it makes.

Documentary Photography Redefined

Postmodern photography of the 1980s built on many of the changes that had come to the art world in the 1970s, especially in the work of women artists. One of these changes was that artists admitted their own involvement with their subjects. As a postmodern photographer, Sally Mann acknowledges a self-conscious role for herself that is more overt and active than that

95. SALLY MANN (American, b. 1951) *Sherry and Sherry's Grandmother, Both at Twelve Years Old.* From *At Twelve: Portraits of Young Women*, 1988. Gelatin-silver print. Houk-Friedman Gallery, New York.

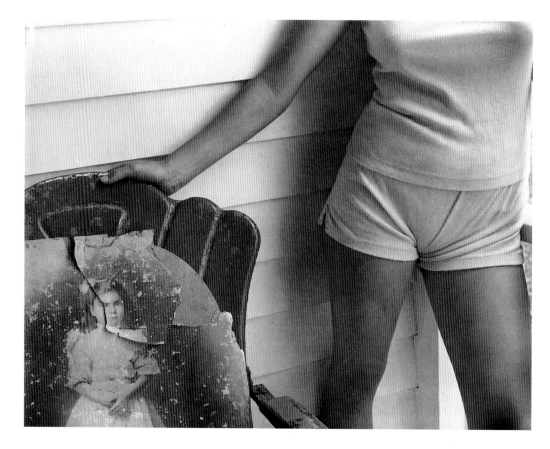

of Modernist photographers. While her subject, the sexuality of children and adolescents, occupied nineteenth- century photographers, her approach is updated. Her book *At Twelve: Portraits of Young Women* (1988), shows photographs of the bodies of girls just entering adulthood. In *Immediate Family* (1992), she photographed her own three children at play, clothed and unclothed, in and around the family home in rural Virginia. Mann's pictures look realistic, in that there is no blatant manipulation of negative or print; however the fact that the pictures are posed removes them from the realm of traditional documentary photography. Her photograph, *Sherry and Sherry's Grandmother, Both at Twelve Years Old* (FIG. 95), does not claim to tell the "truth," but rather is a staged exploration. Mann juxtaposes the actual body of Sherry with a photograph of her grandmother. Both women are represented at the age of twelve. The cultural changes in the fifty or so years that intervene between the two photographs have redefined both photography and adolescence. Unlike the dress that Sherry's grandmother wears, which is delicate and concealing, Sherry's shorts are brief, tight, and reveal the physical, bodily site of emerging womanhood. As has been noted, one can imagine Sherry facing the camera, unaware that it represents a gaze that has "treacherously traveled elsewhere," to make a picture "centering on her pudendum."

Mann's work exhibits the self-consciousness that marks much of the photography of the last fifteen years. With the demise of the belief that a photograph can present a privileged window onto reality and truth, photographers have chosen instead to make pictures that admit to being artifices. The artificiality that posing gives to Mann's work is enhanced by exposure times adjusted to shift certain tones away from the "natural" and towards the abnormally dark. In printing she uses a bleaching agent to lighten some tones and create the appearance of light inexplicably emanating from her subjects, which heightens the theatricality and psychological impact of the work.

Nan Goldin takes a different approach to the representation of women's bodies. This is the subject of her 1986 book of color photographs entitled *The Ballad of Sexual Dependency*, which was developed from her changing slide show of the same title. Goldin's photography is very similar to Larry Clark's, especially the photographs in his book *Tulsa*. Both photographers document sub-groups to which they belong: Clark's is the group of junkies he lived with in Oklahoma; Goldin's is the group of close friends she lived with after she ran away from home,

whom she depended on during a turbulent and, at times, quite self-destructive period in her life. What makes these projects different from traditional documentary photography is the fact that the photographer admits to being a member of the group being photographed. They reject the status of objective observer, a position called into question with postmodernism; instead, they acknowledge the emotional, economic, and psychological ties they have with their subject matter.

Goldin herself appears frequently in her pictures, which function as a kind of diary of her life through troubling times. Yet, as with any diaristic genre, it is never clear how the pictures relate to the "truth." These photographs seem to be a record of Goldin's feelings about herself in her relationships. In *Nan and Brian in bed, New York City, 1983*, Nan is under the covers, looking at Brian, who sits on the side of the bed, absorbed in his own thoughts and smoking a cigarette. A sense of alienation – the separation of one body from another – is very strong. In another picture, *Kenny in his room, New York City*, 1979, a totally undressed male figure sleeps in a room scattered with clothing and papers. Nudity suggests that this view of Kenny may be intimate, but he seems asleep, so the view may also be voyeuristic. Life here is lived recklessly, in the pursuit of creative and romantic passions. Recklessness and passion re-appear, inscribed upon the body, in *Heart-Shaped Bruise, New York City, 1980* (FIG. 96). Here a woman (Goldin?) displays her bruised thigh to the camera. Head and torso are cropped out of the picture, reducing the figure to mere flesh. The bruised thigh seems at first no longer part of a person, but a fragment made from the

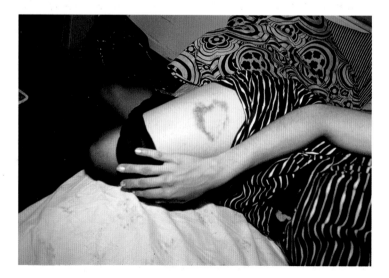

96. NAN GOLDIN
(American, b. 1953)
Heart-Shaped Bruise, New York City, 1980. Color-coupler print. Pace-MacGill Gallery, New York.

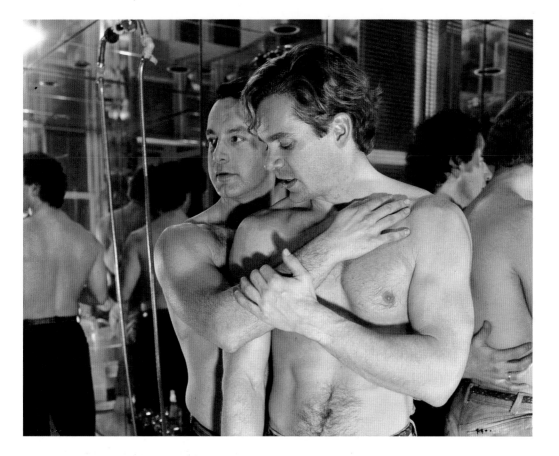

97. TINA BARNEY
(American) *Ken and Bruce*,
1990. Chromogenic color
print, 48 x 60" (121.9 x
152.4 cm). Janet Bourden, Inc,
New York.

female body for the male gaze, conditioned to eroticize that
body part by part. But such erotic (and controlling) fragmenta-
tion is undermined; this results partly from the knowledge that
the photographer is a woman and partly from the context in
which the work appears, which suggests that it is meant at once
to document and unmask the very power conventionally accru-
ing to the male gaze.

Because Tina Barney (like Goldin) is herself a member of the
group that she photographs, a degree of intimacy marks her pic-
tures. The subjects of Barney's first photographs were the super-
affluent, old money families of the East Coast of the United
States. Because Barney is herself a member of that group, these
pictures were marked by a degree of intimacy. At the same time,
a number of factors combined to make them highly artificial.
Barney works with a large camera and tripod, so there is never
any possibility of her pictures being true candid shots. In the
process of setting up her equipment and composing her pictures
she makes her own presence obvious, and the images have the

98. Thomas Struth
(German) *The Ghez Family,
Chicago,* 1990. Color-coupler
print, 5'8" x 7'2" (1.7 x 2.1m).
Marion Goodman Gallery,
New York.

kind of artificiality more commonly associated with staged pictures, like those of Cindy Sherman. In her recent pictures, Barney has explored human relationships within this chosen class of people, rather than just their physical surroundings (FIG. 97).

Thomas Struth and Thomas Ruff, like Barney, also work within traditional unmanipulated photography. Each of them works with a large-format camera to produce very large prints, from 4 x 5 feet for Struth, to 6 x 8 feet for Ruff. The size of these prints gives substance to the content. They read as more than mere enlargements of smaller prints. In the process of enlargement, areas of the photograph that would otherwise escape attention become the subject of observation. Not just the positive forms of the bodies in the photographs, for example, but also the negative spaces surrounding them become palpable.

A student of the German photographers Bernd and Hilla Becher, Struth subjects families to the kind of close study and classification that the Bechers apply to mining structures and cooling towers. His dispassionate views suggest that he is conducting an anthropological study of families throughout the

developed world, taking a scientific look at people who are unaccustomed to being subjected to the disciplined scrutiny that nineteenth-century photographers directed towards colonized people (FIG. 98). He uses the large scale of his prints to hold up to close scrutiny photographs so seemingly simple and straight-forward as to risk not being taken seriously. Struth considers the anthropological richness of his work to lie in small details, the study of which is encouraged by the pictures' size.

Ruff also uses a large scale for his pictures, but he does so for opposite reasons, to suggest that portrait photographs reveal little of the character and psychological insight we frequently attribute to them (FIG. 99). The large size of these prints serves to denaturalize the process of photography and portraiture; we are to see the photographs, and the flesh and clothing they represent, as material objects, mute without our own projections onto them.

99. THOMAS RUFF (German) *Portrait (M. Schell)*, 1990. Color-coupler print, mounted on plexiglass, 7'1" x 5'3" (2.1 x 1.6 m). 303 Gallery, New York.

Other postmodern artists are too self-conscious to try to exert control over the body of another person. Instead, they use their own body as the locus of self-expression and self-revelation. Postmodernism, in line with psychoanalytic and feminist theory, also suggests seeing an individual's personality as a performance rather than a set of fixed characteristics. This way of thinking has encouraged photographers to make pictures in which they "enact" themselves or some other persona. Most act out assumed or fictional roles; they refuse to seek any "true" or "real" self. In addition, in the process of making self-portraits, artists criticize the processes of representation.

Media and the Body in a Consumer Society

Cindy Sherman uses her own body to re-enact the social roles that women play. She is concerned not with a sociological investigation of the actual roles but with how these roles are presented in the media – especially in film and glossy magazines. Her earliest work, from the late 1970s, simulated the look of film stills from black-and-white B-movies. These *Untitled Film Stills*, and the roles Sherman created for herself in them – the young *ingénue*, the starlet, the housewife – evoke films of the 1950s that presented women as vulnerable, weak, and even mad. In the early 1980s, Sherman changed to color and to prints proportioned to suggest Cinemascope movies and *Playboy* center-folds. Unlike the exterior spaces of the black-and-white still photographs, these first works in color brought Sherman's women into interior, private, domestic spaces – spaces culturally defined as feminine. By 1983 Sherman had left the bitter-sweet fantasies

100. Cindy Sherman (American, b. 1954) Untitled, 1992. Color-coupler print. Metro Pictures, New York.

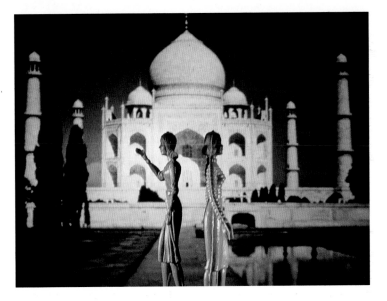

101. LAURIE SIMMONS
(American, b. 1949)
Tourism: Taj Mahal, 1984.
Ciba-chrome, 40 x 60" (101
x 152 cm). Metro Pictures,
New York.

of the 1950s and began making photographs of the female body that became increasingly dark, grotesque, and fragmented. For some of these, which comment on the ways in which women were presented in the visual culture of past generations, Sherman reenacted well-known paintings, sometimes changing the gender of the protagonist from male to female. In another series from the late 1980s, she reduced the female body to its physical by-products: viscera, vomit, menstrual blood. The loss of a coherent, recognizable body begun in this work continued into the early 1990s, in work for which Sherman armored her body with real and fabricated prostheses. These plastic body parts literalize the fetishism of the male gaze (FIG. 100).

Like Sherman, Laurie Simmons and Barbara Kruger investigate representations of women; however, unlike Sherman, they do not use images of themselves. These three women, all white and from comfortable middle-class backgrounds, question the comforting stereotypes promulgated in the American media of the 1950s, when mass culture had created a powerful collective fantasy, undermined in the following decade. Simmons uses the figures of plastic toys to suggest the roles that boys and girls were encouraged to take up during the era of consensus of her own childhood – when the "consumer society" was born. Her work criticizes patriarchal systems of representation. In *Tourism: Taj Mahal* (FIG. 101), tourism is reduced to the consumption of pre-existing imagery, here represented through the full-color image of the monument, before which stand equally mediated figures, plastic female toy dolls.

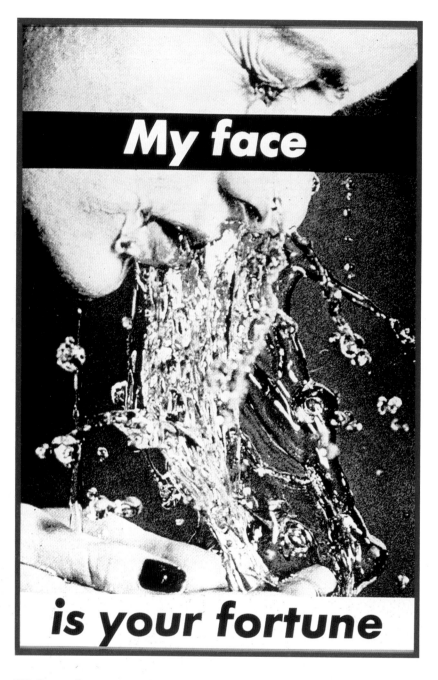

102. Barbara Kruger
(American, b. 1945) *Untitled (My Face is Your Fortune)*, 1982. Gelatin-silver print, 6′ x 3′11″ (1.83 x 1.19m.) Cincinnati Art Museum.

The words that Barbara Kruger uses are less a caption to the picture than the voice of the woman represented, a voice that in conventional media is muted by the overwhelming, overbearing power of the representational system in which the image occurs.

Kruger combines text with appropriated images, using techniques she learned as a graphic designer for various women's magazines that promoted beauty, fashion, and conventional heterosexual relationships. She examines the role of the female body in the media as a marketing vehicle to sell cosmetics, hair care, and fashion to other women. The text that Kruger lays over her images repeatedly uses personal pronouns – I/my, you/yours – to establish direct relationships between the artist or art object and the viewer. Since no specific, fixed identity is referred to by these pronouns, however, the relationships suggested are in flux and uncertain. "I" might refer to Kruger, the viewer, or some fictitious persona; similarly "you" shifts to function differently with male and female viewers. In *Untitled (My Face is Your Fortune)* (FIG. 102), "your" suggests the male who exploits the female body through both commerce and the gaze.

PHILLIPPE DE CHAMPAIGNE (1602-1674) *Deposition,* n.d. Panel, 26²/₃ x 77¹/₂" (68 x 197 cm). Louvre, Paris.

103. MIKE AND DOUG STARN (American, b. 1961) *Ascension,* 1985-1987. Toned silver print, ortho film, tape, wood, glass, 7'6" x 3'4" (2.2 x 1 m).

Other postmodern photographers of the body recycle mythological and other mediated images in their art. Mike and Doug Starn rephotograph earlier paintings. Their *Ascension* (FIG. 103) derives from a seventeenth-century French painting by Philippe de Champaigne, of the deposition of Christ's body. The body of Christ, which scarcely appears in art after the first half of the nineteenth century (Manet and Gauguin painted rare exceptions), reappears here. The acceptability of the Starns's effort – in contrast to the awkwardness of F. Holland Day's 1896 *Crucifixion* (see FIG. 37) – suggests the changes that have occurred in art over nearly a century. Mike and Doug Starn discover a means of achieving with photography what artists

have been doing for centuries: to borrow figures and composi-
tional schema from earlier artistic periods, as a way of indicating
their own rootedness in tradition and thus their own status as
artists. Turn-of-the-century Pictorialists did this to win the sta-
tus of art for photography. Modernists disdained these efforts,
maintaining that imitation of style or motif diminished artistic
originality and value. It is only with postmodernism that artistic
conventions have once again allowed, and encouraged, inten-
tional, self-conscious borrowing.

Luis Gonzales Palma, a young Guatemalan architect turned
photographer, blends Catholic religion and the traditional myths
that permeate the culture of Latin America in a style known as
"magical realism," most familiar through the novels of the
Columbian writer Gabriel Garcia Marquez. Palma's *Corazon I*
("heart"; FIG. 104) embodies myth and religion in a way found

MAGENTA

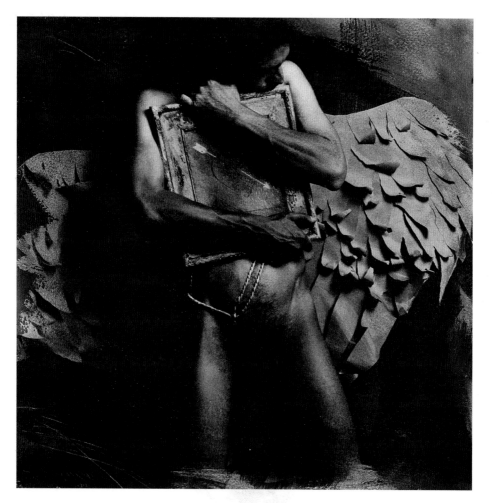

COLORED GIRL

Above 105. CARRIE MAE WEEMS (American, b. 1953) *Magenta Colored Girl*, 1989. Three toned gelatin-silver prints, plastic lettering applied to glazing, 16³/₄ x 49¹/₂″ (42.5 x 126 cm). Spencer Museum of Art, University of Kansas.

By toning the prints, by giving them color, Carrie Mae Weems restates the superficial nature of race: it is mere coloring. She gives evidence, as well, for the richly descriptive terms for flesh tones that exist within the African-American community and provide the basis for a hierarchical ranking of skin colors.

Left 104. LUIS GONZALES PALMA (Guatemalan, b. 1957) *Corazon I (Winged Man With Heart)*, 1989. Sensitized watercolor paper with ink and dyes, 17¹/₂ x 17¹/₂″ (44.4 x 44.4 cm). Spencer Museum of Art, University of Kansas.

throughout Latin America. The photograph is reminiscent of Latin-American baroque painting and sculpture, which sought to capture imagination and soul through the literal representation of the impossible and the horrific. Palma's work becomes, in effect, the artistic verification of nineteenth-century arguments about photography. He clearly disregards objective, visual reality, and instead creates an alternative realm (around something as palpable as the human body) of spirit and feeling.

Carrie Mae Weems and Lorna Simpson focus on the female body as a way to explore not only issues of gender, but also of race. They condemn the very evolution within nineteenth- century photography of the racial body. Their pictures point out photography's complicity in the production of race and racism, especially within the social and biological sciences of the nineteenth century, and parody the social construction of such issues around the body. Weems and Simpson try to expose the economic and psychological origins of such issues, showing how what seems essential is instead culturally and historically determined. Weems's *Magenta Colored Girl* (FIG. 105) exists at the intersection of photography and race, image and text. Lorna Simpson's work similarly depends upon attitudes that exist outside the work of art. Her *Guarded Conditions* (FIG. 106) of 1989 is, like Weems's *Magenta Colored Girl*, the visualization of a verbal pun. Simpson's piece is made up of eighteen color photographs that show an African-American woman from the back six times. It is unclear if the same woman is photographed six times or if it is six different women, which suggests the anonymity of blacks in white-dominated society. Like all the figures in Simpson's

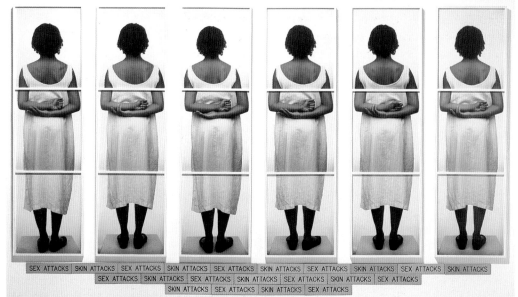

GUARDED CONDITIONS

SEX ATTACKS | SKIN ATTACKS | SEX ATTACKS | SKIN ATTACKS | SEX ATTACKS | SKIN ATTACKS | SEX ATTACKS | SKIN ATTACKS | SEX ATTACKS | SKIN ATTACKS
SEX ATTACKS | SKIN ATTACKS | SEX ATTACKS | SKIN ATTACKS | SEX ATTACKS | SKIN ATTACKS | SEX ATTACKS
SKIN ATTACKS | SEX ATTACKS | SKIN ATTACKS | SEX ATTACKS

106. LORNA SIMPSON (American, b. 1960) *Guarded Conditions*, 1989. 18 dye-diffusion Polaroid prints; 21 plastic plaques, 7′7″ x 10′11″ (2.3 x 3.3 m). Museum of Contemporary Art, San Diego, California.

work, she is faceless, implying that she has no voice or subjectivity of her own. The arms are held together, in the small of the back, suggesting unease. Beneath the images Simpson has placed twenty-one plastic plaques, on which appear either the words "skin attacks" or "sex attacks," verbalizing the double vulnerability of black women. The body is also at the center of work in which Simpson explores different kinds of hairstyles, which she connects satirically with racial identity.

A similar critique comes from the French artist Annette Messager. She self-consciously concerns herself with depictions of the body in nineteenth-century photography, especially the control exerted over it in medical and legal contexts. She begins with a recognition, as she said in a 1989 interview, that "photography as a reproductive technique was very closely involved with bodies – with sick bodies and the body as social phenomenon, with 'exotic' bodies and the body as an erotic object." Imitating photographers from the last century, Messager always poses her models and produces black-and-white images. From these photographs, she extracts details of the body: feet, hands, nipples, nose, mouth, eyes, pubic area. She puts these into individual frames and then arranges them hanging from strings in a cluster (FIG. 94).

AIDS, Gay Liberation, and the Homoerotic Body

In the 1980s and 1990s, the male body took on a new cultural and political importance. Robert Mapplethorpe made homoerotic photographs in the tradition of von Gloeden and F. Holland Day, at the turn of the century, and of Minor White in the 1950s and 1960s. Like these earlier examples, Mapplethorpe's photography functions as erotica for gay men while making male homosexuality visible (FIG. 107). Just as Stieglitz's portrait of O'Keeffe defined both parties – photographer and model – as sexual and straight, Mapplethorpe's pictures assign to model and maker a homosexualized position. In common with Day and von Gloeden, Mapplethorpe's eroticism crosses racial and ethnic lines.

Mapplethorpe's photographs have power to generate argument concerning sexuality of all kinds, while giving representation to male homosexuality in the time of AIDS. They point up

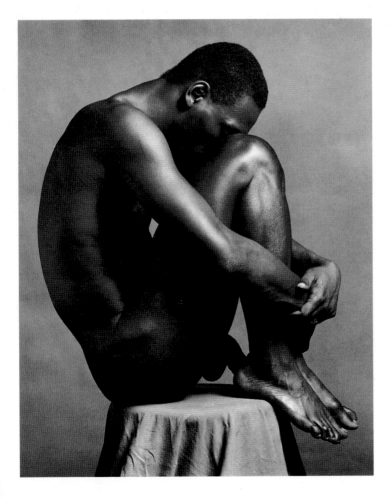

107. ROBERT MAPPLETHORPE (American, 1946-1989) *Ajitto,* 1981. Gelatin-silver print.

108. ROSALIND SOLOMON
(American, b. 1930) Untitled.
From *Portraits in the Time of
Aids.* 32 x 32" (81.2 x 81.2
cm).

the way in which sex is used to market everything from jeans
and cars to cigarettes, but only works if the sexual message
remains subliminal. To present highly sexualized imagery with-
out sublimination and not under the guise of advertising or art
presents a challenge by destroying the repression upon which the
use of sex in advertising depends.

Mapplethorpe's photographs must also be seen in the context
of the social and political anxiety of the 1980s. Conservative val-
ues were in the ascendant, most notably with the administrations
of Margaret Thatcher in Great Britain, and of Ronald Reagan
and George Bush in the United States. As part of a backlash
against feminists, lesbians, and gays, conservative social pro-
grams aimed at the retraction of many sexual freedoms gained
ground during the 1970s. In this atmosphere, sexual "looking"
became problematic. Mapplethorpe's work successfully reani-
mated discourse on pornography in general, by blurring the
lines between art and pornography. Mapplethorpe's pho-
tographs were created, seen, and reviewed within the context of
this spirited debate, and perhaps had their greatest importance in
crystallizing its terms.

The cultural and political anxiety of the 1980s was also
expressed through the bodies and lives of children, producing a

new concern over their treatment. Perhaps paralleling the Victorian period, children came to be seen as sexual beings. Questions arose over the role of sex education in public schools, the availability of contraception to children, and teenage pregnancy. Like the work of Charles Dodgson, Mapplethorpe's pictures sexualize children, and allow the viewer to project his or her own sexual fantasies, desires, and anxieties onto the young sitters.

Mapplethorpe is far from being the only photographer whose works raise the subjects of AIDS and homoeroticism. Other photographers have documented the ravaging effects of AIDS on the community of gay men. They include, in the United States, Nick Nixon and Rosalind Solomon, who have aimed in their photography to present a clinically objective view of the homosexual body destroyed by AIDS (FIG. 108). Less documentary approaches have been followed by Peter Hujar and David Wojnarowicz. Hujar's photographs combine eroticism and documentation. His decision to portray nude gay men who are well known, and whose identities are given in the captions, is a political act. The subjects of these pictures are not conventionally appealing models of the kind that Mapplethorpe used (and who are virtually anonymous – only their first names are given). They are known critics, artists and writers. These pictures come close to Stieglitz's portrait of O'Keeffe; they depict nude subjects whose sexuality and sexual orientation is documented in the picture.

Andres Serrano's photographs deal with related contemporary issues of sexuality and politics. Working within what he considers to be a purely formal discourse, he has made large color abstractions that show expansive areas of milk, blood, urine, and semen. While he claims that he uses these body fluids only for their rich colors, his work must be understood in the context of contemporary anxiety over the human body, gender, and sexuality. Serrano's liquids refer specifically to the conditions – blood/semen contact – through which the HIV virus is transmitted. His photographs are icons of the age of AIDS, bringing together as an oeuvre bodily fluids, religion, and the human body. Serrano became a *cause célèbre* for his *Piss Christ* of 1987 (FIG. 109), a large color photograph of a crucifix immersed in the slightly effervescent yellow liquid of the artist's own urine. It has been written that in this work the artist might be trying to make "a connection between his own corporeality and the figure of Christ, implying a humanization of the religious figure, but also, more significantly, giving a spiritual meaning to his own body from which he felt disconnected." Serrano has also

109. ANDRES SERRANO (American, b. 1950) *Piss Christ*, 1987. Cibachrome, silicone, plexiglass, wood frame, 60 x 40″ (152 x 101 cm). Paula Cooper Gallery, New York.

photographed his own semen in the air as he ejaculates, and in other works (having surreptitiously gained access to morgues), he has photographed corpses in defiance of legal prohibitions designed to protect the rights and dignity of the dead. In distinction to Liebling's cadaver (see FIG. 81), which is clearly removed from life through aging, embalming, and dissection, Serrano's corpses seem almost alive, with a blue-veined whiteness somewhere between an infant's new flesh and a marble figurine; they suggest less the old age and the violence of Liebling's photographs than the fragility of life, and the ways of dying in the 1990s other than old age. How nearly alive the bodies seem, and yet how final is their separation from the realm of the living!

Politics and Critiques of Formalism

John Coplans breaks the taboo that has existed since the mid-nineteenth century – that the heterosexualized male body should not be explored or represented in visual culture. Coplans began photographing his own body in 1984, when he was sixty-four years old. These faceless, close-up, intimate pictures are Edward Weston run amok. Like Weston's pictures they are abstract, but unlike Weston, who endows the bodies of his female subjects with eroticism and elegance, Coplans refuses to flatter his own image. He draws attention to his age by distorting his body and exposing graying chest hair, calloused feet, and thickened toenails (FIG. 110). Despite this seemingly cruel self-exposure, Coplans retains the male prerogative of control: there is no other person, no outsider looking in. In showing a man's body, especially an older man's body, Coplans joins Mapplethorpe in making visible what convention has repressed: the physical, naked form of the male as the object of the gaze.

Coplans's photographs may reflect the aging of the American baby-boomers, the exceptionally large generation born between the late 1940s and late 1950s, who at each point in their lives have seen themselves in the cultural and media spotlight. Having established the notion of a "youth culture" in the 1960s and 1970s, they now find themselves facing middle age for themselves, and old age for their parents. Coplans is older than this generation, but the production and reception of his work may represent the baby-boomers' middle-aged recognition of mortality.

In the postmodern era, the position of straight, white men at the dominant center of society, previously thought to be unalterable and ideal, can be seen as artificial and problematic.

110. John Coplans (British, b. 1920, active United States). *Self-Portrait: Feet Frontal*, 1984. Gelatin-silver print, 57 x 37" (145 x 94 cm).

Coplans's works suggest such a shift. His self-portraits remind the viewer of the work of Egon Schiele and, much later, Arnulf Rainer and Lucas Samaras; they may allude to performance and body art, but they seem closer to the tradition of straight, Modernist photography. Coplans's photographs are unadulterated silver prints, without alterations, and his refusal to manipulate his images gives them their power. He chooses to connect his photographs formally with the tradition of high Modernism and exploits this connection to imply a critique of the earlier work; his own production points up the exclusion of the male body

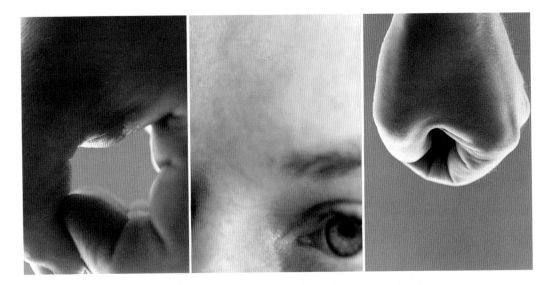

111. THOMAS FLORSCHUETZ
(German) *Untitled Triptych
no. 7*, 1988-1990. 5'11" x
11'11" (1.8 x 3.6 m).
Collection Christoph Tannert,
Berlin.

from that earlier aesthetic – the absence particularly of Stieglitz's and Weston's own bodies.

Coplans's depiction of a body at once formalist and political is echoed in the work of the German photographer Thomas Florschuetz. By working with fragments of the human body, removed from normal contexts and scale, Florschuetz at once denaturalizes the body and reconstructs it as richly sensual, and full of sexual possibilities (FIG. 111). To treat the body in this manner at a time when sexuality is feared, and the sensuality of the flesh forgotten or lost in an onslaught of cybernetic stimulation, from computer screens and video cables, is intensely political.

Other photographers whose work investigates political topics are Fred Lonidier in the United States, Jo Spence and Terry Dennett, who worked collaboratively in Great Britain, the Guerrilla Girls collective, again in the United States, and Bernhard and Anna Blume, in Germany. While Lonidier's picture of an office worker's wrist has the formal qualities of Weston's abstract photographs of sand dunes and female nudes, the issue in Lonidier's work is politics, not aesthetics (FIG. 112). Attached to the photograph are its title (*Office Worker's Nerves*) and a caption, a quotation from the worker: "She didn't give me the forms because she didn't want her record to look bad. It was for her own future promotion." Lonidier is not concerned with the look of the wrist but with the damage suffered, probably to the carpel tunnel, which protects the nerves as they pass through the wrist joint and which can become inflamed and hardened from excessive use of typewriter and computer keyboards. Lonidier's picture is from his series *The Health and Safety Game*, in which

he explores the damage to the human body sustained in the work place.

Part of the postmodern agenda is to reevaluate the art of the past. Spence and Dennett rewrite the history of photography more explicitly than do Coplans or Lonidier, reminding us of all that has been left out of formalist photography and formalist histories of photography. *Industrialization* (FIGS. 113 and 114), from the series *Remodelling Photo-History* seems, like Lonidier's work, to comment on the work of Edward Weston and other photographers who constructed a high Modernist photography around the nude female body. Spence and Dennett begin their critique of Modernism by working with a female body that is not idealized, that is closer to the realm of Coplans's body. Instead of positioning it in some rarified, transcendent space, away from the contingencies of real work, they place it in a landscape marred by high-tension electrical lines, thus removing it from the idealized realm. After Spence received a diagnosis of breast cancer in 1982, she and Dennett also explored the meanings society has given to women's breasts.

Even more political are the photographs made by the Guerrilla Girls, an activist group of feminist artists who attack the representation of women artists within the institutions of art. The photographs are used in wall posters and broadsides that the

112. FRED LONIDIER
Office Worker's Nerves
(detail). From *The Health and Safety Game*, 1976.
Photo/text/video installation, 16 x 20″ (40.6 x 50.8 cm).

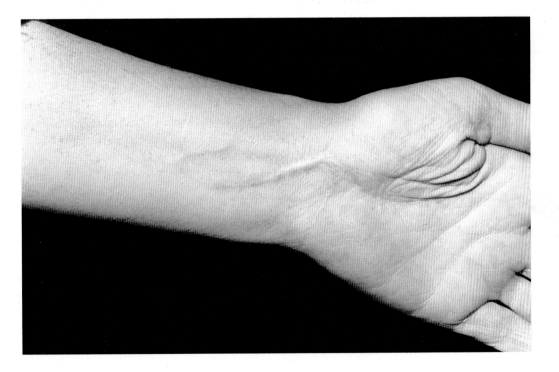

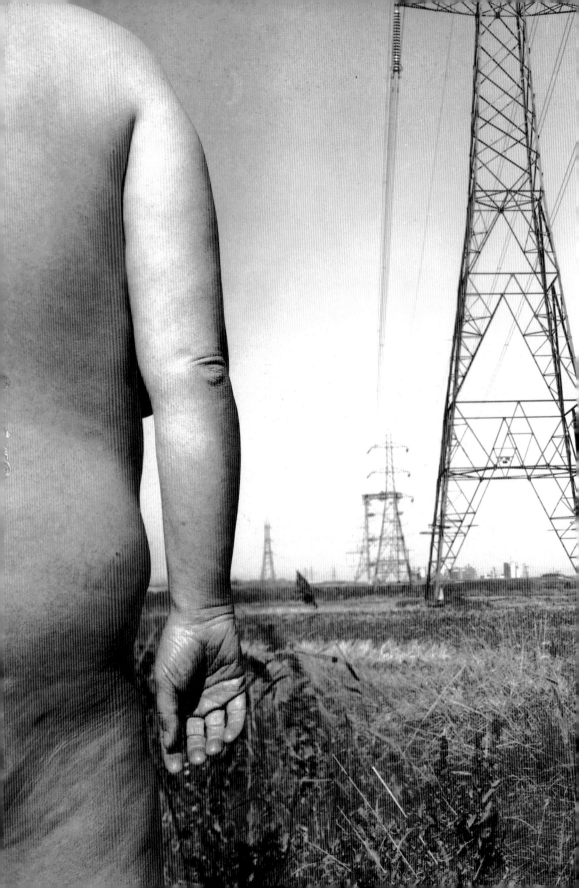

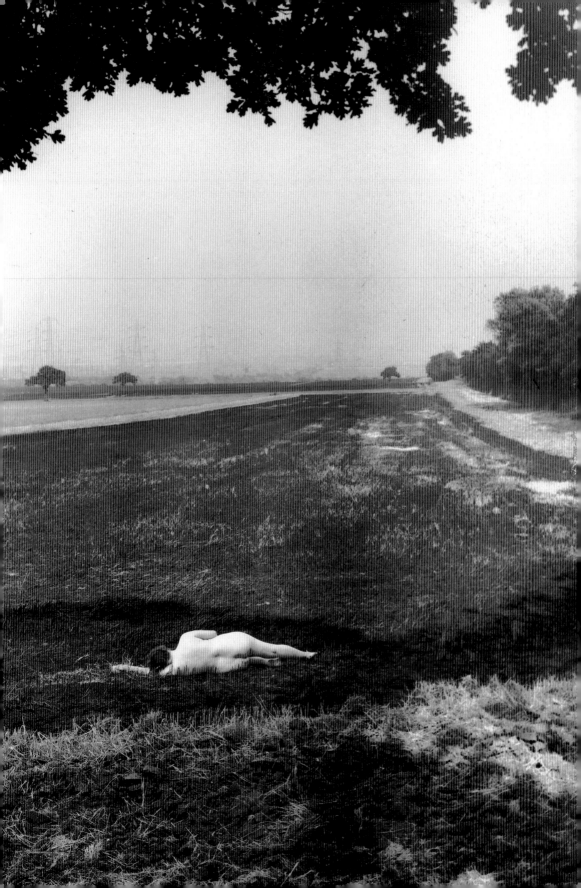

group affixes illegally (as a guerrilla activity) to walls in New York's Soho gallery district. In *Do women have to be naked to get into the Met. Museum?* (FIG. 115), the Guerrilla Girls criticize the traditional position of women within visual culture as objects of the male gaze, rather than as producers of art. The Guerrilla Girls comment upon the female body in three ways. First, they examine the culturally defined gender differences traditionally assigned to women on the basis of their bodies. Second, they consider the reinforcement of such differences in the depiction of women as nude bodies throughout the history of art. And third, they hide their own identities, often under gorilla-like face masks, during their political interventions. Hiding their faces protects individuals from retribution, and de-emphasizes the individual action, allowing those involved to stand for all women artists attacking patriarchal systems. Their actions also function as masquerades: the gorilla mask reinforces the idea of woman as "other" and at the same time protects them from the male gaze, deflecting it and its power.

Bernhard and Anna Blume's recent photographs in their series *Im Wald (In the Forest),* undercut the tradition of land-scape art (FIG. 116). Building on earlier work, for which they enacted performances exclusively to be photographed, the Blumes, dressed conservatively in business suits, put themselves among the trees of a dense forest. The presence in these pictures of the human body serves to remind us of the extent to which

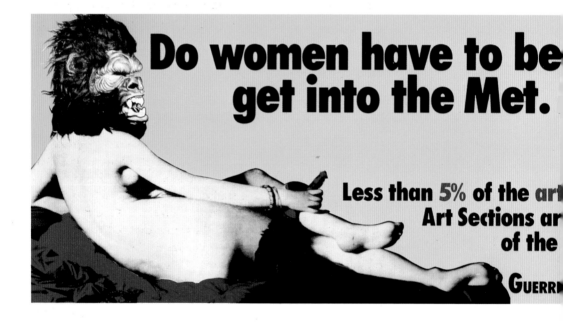

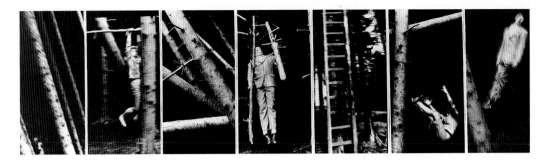

116. ANNA and BERNHARD BLUME (German) *Metaphysik ist Männersache (Metaphysics is Man's Business)*, 1990. From the series *Im Wald (In the Forest)*. 7 gelatin-silver prints, 4'1" x 8'2" (1.2 x 2.5 m).

ideas about nature are created by human beings. In photographing forests, the Blumes are also investigating a subject at once dear to the German people and threatened by pollution.

The politics of labor, the work of the body, has also been a subject of recent photography. Alfredo Jaar first photographed the Serra Pelada mine in Brazil in 1985. At this large, open-pit gold mine, he made a series of portraits of workers, which he printed in a large format on cheap paper and installed in place of advertising in a New York City subway station. There was no indication that these were art and not advertisements; the only accompanying texts were listings of the price of gold in various world markets.

Several years after Jaar had photographed at Serra Pelada, the mine workers were photographed again by Sabastiaõ Salgado. An economist, Salgado first made photographs to illustrate reports he was preparing as part of his work for the World Bank, finding that photographs conveyed his meaning more forcefully than words. His photographs of the Serra Pelada mine were undertaken as part of his *End of Manual Labor* series (FIG. 117). Salgado works within the tradition of liberal photo-journalism, following especially in the tradition of W. Eugene Smith, a Life photographer who, like Salgado, used a ferro-cyanide solution to bleach parts of his prints to lighter tones.

Work that is less explicitly political, but still evocative of a politicized world, is made by Christian Boltanski. Born during the Second World War, Boltanski makes photographs that evoke the loss of life during that period, especially in concentration camps. He makes installations of photographic portrait heads that are mounted, not framed, on rusty sheet steel and lit primitively, with bare light bulbs whose exposed wiring hangs down in front of and partially obscures the images (FIG. 118). By calling these installations "altars," Boltanski makes them act as monuments to dead souls. The choice of materials suggests a postmodern culture constructed on the ruins of the industrial

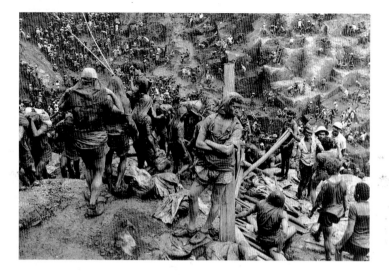

117. Sabastiaõ Salgado
(Brazilian, b. 1944)
Untitled (Serra Pelada mine).
From the series *The End of Manual Labor*, 1968. 16 x 20"
(40 x 50 cm).

Like Walker Evans's Depression-era photographs of sharecroppers, Sabastiaõ Salgado's Serra Pelada pictures record bodies at work. The title of Salgado's series, *The End of Manual Labor*, suggests the increasing rarity of physical labor, at least in developed countries, where white-collar manipulators of words and figures dominate the job market.

age. Electric lights for example, seem to be only fragments recovered from an earlier, more successful culture. What destroyed this earlier culture is only suggested, but one senses references to the Holocaust or to an imagined nuclear disaster. The message expressed by Boltanski and other postmodernist photographers is the hope that their works will help avert such a future.

118. Christian Boltanski
(French, b. 1944)
Monument Odessa, 1991.
Black and white photographs, lights, electric wire, 7'2" x 3'5"
(2.1 x 1m).

Bibliography

GENERAL HISTORIES

NEWHALL, BEAUMONT, *The History of Photography from 1839 to the Present* (5th ed. New York: Graphic Society Books, 1982), is the classic English-language history of photography. First written for a 1937 exhibition at the Museum of Modern Art, Boston, it is at its best as a historiography and documents the modernist canon of photographers.

ROSENBLUM, NAOMI, *A World History of Photography* (New York: Abbeville Press, 1984), has extensive illustrations and exhaustive information.

SZARKOWSKI, JOHN, *Photography Until Now* (exh. cat., New York: The Museum of Modern Art, 1989), fuses technical, social, and aesthetic histories of photography.

ANTHOLOGIES

BOLTON , RICHARD (ed.), *The Contest of Meaning: Critical Histories of Photography* (Cambridge, Mass., and London: MIT Press, 1989)

SQUIERS, CAROL (ed.), *The Critical Image: Essays on Contemporary Photography* (Seattle: Bay Press, 1990)

WALLIS, BRIAN (ed.), *Art After Modernism: Rethinking Representation* (New York: The New Museum of Contemporary Art, 1984; Boston: David R. Godine, 1984)

POSTMODERNISM – ANTHOLOGIES

EAGLETON, TERRY, *Literary Theory: An Introduction* (Minneapolis: University of Minnesota Press, 1983)

FOSTER, HAL (ed.), *The Anti-Aesthetic: Essays on Postmodern Culture* (Seattle: Bay Press, 1983)

HUTCHEON, LINDA, *The Politics of Postmodernism* (London and New York: Routledge & Kegan Paul, 1989)

OWENS, CRAIG, *Beyond Recognition: Representation, Power, and Culture* (Berkeley and Oxford: University of California Press, 1992), contains essays by a seminal writer, especially on postmodernism.

SARUP, MADAN, *An Introductory Guide to Post-Structuralism and Postmodernism* (Athens, Ga.: University of Georgia Press, 1989)

THE BODY

ADLER, KATHLEEN, AND MARCIA POINTON (eds), *The Body Imaged: The Human Form and Visual Culture Since the Renaissance* (Cambridge: Cambridge University Press, 1993)

GALLOP, JANE, *Thinking Through the Body* (New York: Columbia University Press, 1988)

HUNT, LYNN (ed.), *Eroticism and the Body Politic* (Baltimore and London: The Johns Hopkins University Press, 1990)

NEAD, LYNDA, *The Female Nude: Art, Obscenity, and Sexuality* (London and New York: Routledge & Kegan Paul, 1992)

POINTON, MARCIA R., *Naked Authority: The Body in Western Painting 1830-1908* (Cambridge: Cambridge University Press, 1990)

SULEIMAN, SUSAN RUBIN, *The Female Body in Western Culture: Contemporary Perspectives* (Cambridge, Mass., and London: Harvard University Press, 1986)

WEIERMAIR, PETER, *Verborgene Bild. [The hidden image: photographs of the male nude in the nineteenth and twentieth centuries]* (trans. Claus Nielander. Cambridge, Mass.: MIT Press, 1988)

FEMINIST AND PSYCHOANALYTIC THEORY

BARRETT, MICHELE, AND ANNE PHILLIPS (eds), *Destabilizing Theory: Contemporary Feminist Debates* (Stanford: Stanford University Press, 1992)

BUTLER, JUDITH, *Gender Trouble: Feminism and the Subversion of Identity* (New York and London: Routledge, 1990)

FELDSTEIN, RICHARD, AND JUDITH ROOF (eds), *Feminism and Psychoanalysis* (Ithaca and London: Cornell University Press, 1989)

FERGUSON, KATHY E., *The Man Question: Visions of Subjectivity in Feminist Theory* (Berkeley and Oxford: University of California Press, 1993)

KUHN, ANNETTE, *The Power of the Image: Essays on Representation and Sexuality* (London, Boston, Melbourne, and Henley: Routledge & Kegan Paul, 1985)

MULVEY, LAURA, *Visual and Other Pleasures* (Bloomington and Indianapolis: Indiana University Press, 1989), applies psychoanalytical notions of the "gaze" to film criticism.

WRIGHT, ELIZABETH (ed.), *Feminism and Psychoanalysis: A Critical Dictionary* (Oxford and Cambridge, Mass.: Basil Blackwell, 1992)

CHAPTER ONE

BANTA, MELISSA, AND CURTIS M. HINSLEY, *From Site to Sight: Anthropology, Photography, and the Power of Imagery* (Cambridge, Mass.: Peabody Museum Press, 1986)

BRAUN, MARTA, *Picturing Time: The Work of Etienne-Jules Marey (1830-1904)* (Chicago: University of Chicago Press, 1992), is an excellent source, not only for Marey, but also for photographic motion studies in general.

EDWARDS, ELIZABETH (ed.), *Anthropology and Photography 1860-1920* (New Haven: Yale University Press, 1992), contains essays on the interactions between anthropology and photography.

FERGUSON, RUSSELL, MARTHA GEVER, TRINH T. MINH-HA, AND CORNEL WEST (eds), *Out There: Marginalization and Contemporary Cultures* (New York: The New Museum of Contemporary Art; Cambridge, Mass., and London: MIT Press, 1990), is especially valuable for essays by Homi K. Bhabha and James Clifford that apply psychoanalytical and feminist notions of the fetish, the gaze, and the "other" to an interpretaion of nineteenth-century Europe's

relationship to colonized people.

FOUCAULT, MICHEL, *Discipline and Punish: The Birth of the Prison* (trans. Alan Sheridan. New York: Pantheon, 1977)

——, *The History of Sexuality. Vol. 1: An Introduction* (trans. Robert Hurley. New York: Vintage Books/Random House, 1978)

HOLLAND, PATRICIA, JO SPENCE, AND SIMON WATNEY (eds), *Photography/Politics Two* (London and New York: Methuen, 1986), is especially valuable for Mark Green's essay on Galton and eugenics.

SAID, EDWARD, *Orientalism* (New York: Vintage Books/Random House, 1979)

TAGG, JOHN, *The Burden of Representation: Essays on Photographies and Histories* (Minneapolis: University of Minnesota Press, 1988), is a crucial source for understanding the notion of photographic realism. He also discusses the use of photography within the criminal justice system to create fixed identities.

CHAPTER TWO

COOPER, EMMANUEL, *The Sexual Perspective: Homosexuality and Art in the Last 100 Years in the West* (London and New York: Routledge & Kegan Paul, 1986), is a useful survey.

MICHAELS, BARBARA L., *Gertrude Käsebier: The Photographer and Her Photographs* (New York: Harry N. Abrams, 1992), is an excellent source on Käsebier and other women Pictorialists.

NEAD, LYNDA, *Myths of Sexuality: Representations of Women in Victorian Art* (Oxford and New York: Basil Blackwell, 1988)

GARBER, MARJORIE, *Vested Interests: Cross-Dressing and Cultural Anxiety* (New York: Routledge & Kegan Paul, 1992)

ROPER, MICHAEL, AND JOHN TOSH (eds), *Manful Assertions: Masculinities in Britain Since 1800* (New York and London: Routledge & Kegan Paul, 1991)

SHARF, AARON, *Art and Photography* (London: Allen Lane, 1968)

SILVERMAN, KAJA, *Male Subjectivity at the Margins* (New York: Routledge, 1992)

WILLIAMS, LINDA, *Hard Core Power, Pleasure, and the "Frenzy of the Visible"* (London, Sydney, and Wellington: Pandora Press, 1990), suggests that photography serves pornography by subjecting female sexuality to a male-dominated scopic regime.

CHAPTER THREE

EVANS, SARA M., *Born for Liberty: A History of Women in America* (New York: The Free Press, 1989)

KRAUSS, ROSALIND E., *The Originality of the Avant-Garde and Other Modernist Myths* (Cambridge, Mass., and London: MIT Press, 1985), is especially valuable for what Krauss calls the "photographic conditions of surrealism."

——, *The Optical Unconscious* (Cambridge, Mass.: MIT Press, 1993)

KRAUSS, ROSALIND, AND JANE LIVINGSTON, *L'Amour fou:*

Photography and Surrealism (exh. cat., Washington, D.C.: The Corcoran Gallery of Art; New York: Abbeville Press, 1985), has very readable essays.

DOANE, MARY ANN, *The Desire to Desire: The Woman's Film of the 1940s* (Bloomington and Indianapolis: Indiana University Press, 1987), introduces the idea of women's masquerade.

SEDGWICK, EVE KOSOFSKY, *Epistemology of the Closet* (Berkeley: University of California Press, 1990), discusses the importance for modern society of the late nineteenth-century codification of a hetero/homosexual opposition.

CHAPTER FOUR

SZARKOWSKI, JOHN, *Mirrors and Windows: American Photography Since 1960* (exh. cat., New York: The Museum of Modern Art, 1978), contains excellent background on the period.

TRACHTENBERG, ALAN, *Reading American Photographs* (New York: Hill and Wang, 1989), is the source of the comment on Evans's reading of nineteenth-century French authors.

CHAPTER FIVE

GREEN, JONATHAN, *American Photography: A Critical History 1945 to the Present* (New York: Harry N. Abrams, 1984), is a survey that introduces photographs but also criticism and exhibitions.

GOLDBERG, VICKI, *The Power of Photography: How Photographs Changed Our Lives* (New York: Abbeville, 1993), is an expanded and updated edition that looks at the context in which important press photographs were produced.

CHAPTER SIX

BARRIE, LITA, "Art and Disembodiment," *Artweek*, 4 October 1990: 23-24, makes the observation regarding Serrano quoted on page 159.

BILLETER, ERIKA (ed.), *Self-Portrait in the Age of Photography: Photographers Reflecting Their Own Image* (Lausanne: Musée Cantonal des Beaux-Arts, 1985), is one of two important surveys from the mid-1980s of self-portrait photography from a postmodern perspective.

FUSS, DIANA (ed.), *Inside/Out: Lesbian Theories, Gay Theories* (New York: Routledge & Kegan Paul, 1991)

HEARN, JEFF (ed.), *Men in the Public Eye: The Construction and Deconstruction of Public Men and Public Patriarchies* (New York and London: Routledge & Kegan Paul, 1992)

HONNEF, KLAUS, *Lichtbildnisse: das Portrait in der Fotografie* (Köln: Reinland-Verlag, 1982)

MALCOLM, JANET, review of Sally Mann, *Immediate Family,* in the *New York Review of Books*, 3 February 1994: 7, is the source for the description of Sally Mann's photography on page 145.

MIT LIST Visual Arts Center, Cambridge, Mass., *Corporal Politics* (exh. cat., MIT LIST and Boston: Beacon Press, 1992)

Staging the Self: Self-Portrait Photography 1840s-1980s (exh. cat., London: National Portrait Gallery and Plymouth: Plymouth Arts Centre, 1986)

Picture Credits

Collections are given in the captions alongside the pictures. Additional information, copyright credits and photo sources are given below. Numbers to the left refer to figure numbers unless otherwise indicated.

Title page: detail of 22
page 7 detail of 13
1 © Dieter Appelt, courtesy Sander Gallery, New York
2 Richard Long, *Walking in Circles*, The South Bank Centre and the Anthony d'Offay Gallery, London, 1991: 60
page 13 top detail of 18
4 Spencer Museum of Art, University of Kansas, gift of Miss Stella Aten
6 Spencer Museum of Art, University of Kansas, gift of James R. Heffern
page 18 Henry E. Huntington Library and Art Gallery, San Marino, California
7 Cincinnati Art Museum, Ohio # 1978.205. Library Transfer
10 Reproduced by permission of the Archives, Imperial College, London
12 The Museum of Modern Art New York, gift of Paul F. Walter. Copy print © 1994 The Museum of Modern Art, New York
page 37 top detail of 31
19 Cincinnati Art Museum, Ohio # 1983.509, gift of Emilie L. Heine in memory of Mr. and Mrs. John Hauck, by exchange
page 38 RMN, Paris
23 © A.P. Watt Ltd on behalf of The Executors of the C.L.Dodgson Estate
27 The Oakland Museum, California, gift of Mr. & Mrs. W.M. Nott A65.163.53. Photo: Camera Corner, Oakland
34 copy photo Lee Stalsworth
page 65 top detail of 44. © Brassaï Estate, Paris
38 Collection of the Center for Creative Photography, University of Arizona, Tucson
page 70 British Film Institute, London
41 1978, 1994 The Imogen Cunningham Trust
42 The Museum of Modern Art, New York. Given anonymously
43 © Estate of André Kertész, New York
44 © Brassaï Estate, Paris
45 © Editions Filipacchi, Paris
46 © G. Ray Hawkins Gallery, Santa Monica, California
47 Collection Ann & Jürgen Wilde, Zülpich
48 Spencer Museum of Art, University of Kansas, Peter T. Bohan Fund
51 Graphische Sammlung Albertina, Vienna
52 Cincinnati Art Museum, Ohio # 1976.31, The Albert P. Strietmann Collection/© DACS 1995
53 ©DACS 1995
54 © Simon Lowinsky Gallery, New York. Collection Spencer Museum of Art, University of Kansas, Peter T. Bohan Fund
page 89 detail of 62. © Lee Miller Archives, East Sussex
55 © Walker Evans Archive, The Metropolitan Museum of Art, New York
57 © Helen Levitt, courtesy Laurence Miller Gallery, New York. Collection Spencer Museum of Art, University of Kansas, Peter T. Bohan Fund
58 © Gordon Parks
59 © Estate of Marion Palfi
60 © 1994 International Center of Photography, New York. Bequest of Wilma Wilcox
61 National Museum of Canada, Ottawa, gift of the Estate of Lisette Model, 1990, by direction of Joseph G. Blum, New York, through the American Friends of Canada
62 © Lee Miller Archives, East Sussex
63 © George Hoyningen-Huené
64 © Harry Callahan, courtesy Pace/MacGill Gallery, New York. Copy print © 1994 The Museum of Modern Art, New York
page 105 British Film Institute, London
66 © Doisneau/Rapho/Network
67 © Robert Rauschenberg/DACS, London/VAGA, New York 1995. Collection Milwaukee Art Museum, gift of Mr. and Mrs. Irving D. Saltzstein
68 Reproduction courtesy the Minor White Archive, Princeton University. Copyright © 1989 by the Trustees of Princeton University. All Rights reserved
page 113 top detail of 86. © Katharina Sieverding/photo Klaus Mettig, Düsseldorf
69 © Martha Rosler, courtesy the artist
70 Copyright © 1965 Arnold Newman, courtesy the artist
71 Associated Press, London
72 © Estate of Larry Burrows, courtesy Laurence Miller Gallery, New York
73 © Thomas Weir. Collection Spencer Museum of Art, University of Kansas, gift of Mrs. Mark A. Lucas
page 119 © Warner Bros Record
74 © Jean-François Bauret. Collection Spencer Museum of Art, University of Kansas, gift of Esquire Inc.
75 © Ray Metzker, courtesy Laurence Miller Gallery, New York. Collection Spencer Museum of Art, University of Kansas, Peter T. Bohan Fund
76 © Lee Friedlander. Collection Spencer Museum of Art, University of Kansas, gift of Esquire Inc.
77 © Estate of Diane Arbus 1972
78 © Jill Krementz. Collection Spencer Museum of Art, University of Kansas, gift of Esquire Inc.
79 © Andy Warhol Foundation, New York. Collection Spencer Museum of Art, University of Kansas, gift of Esquire Inc.
80 © Larry Clark
81 © Jerome Liebling, courtesy the artist
82 © Carolee Schneemann, courtesy the artist
83 © Estate of the artist, courtesy Ronald Feldman Fine Arts, New York
84 © The Estate of Ana Mendieta
85 © Dennis Oppenheim, courtesy the artist
86 © Katharina Sieverding/photo Klaus Mettig, Düsseldorf
87 © DACS 1995
88 © Robert Cumming, courtesy the artist
89 © Duane Michals, courtesy the artist
90 © Lucas Samaras, courtesy Pace/MacGill Gallery, New York. The Museum of Modern Art, New York, gift of Robert and Gayle Greenhill. Copy transparency © 1994 The Museum of Modern Art, New York
91 © Arnulf Rainer
92 © ARS, NY, and DACS, London 1995
93 © Jürgen Klauke, courtesy the artist
page 143 detail of 116. © Anna & Bernhard Blume, courtesy the artists
94 © Annette Messager, courtesy Galérie Crousel-Robelin Bama, Paris
95 © Sally Mann, courtesy Houk Friedman, New York
96 © Nan Goldin
97 © Tina Barney
98 © Thomas Struth, courtesy Marian Goodman Gallery, New York
99 © Thomas Ruff, courtesy 303 Gallery, New York
100 © Cindy Sherman, courtesy the artist and Metro Pictures, New York
101 © Laurie Simmons, courtesy the artist and Metro Pictures, New York
102 © Barbara Kruger, courtesy Mary Boone Gallery, New York
page 153 top RMN, Paris
103 © ARS, NY, and DACS, London 1995
104 © Luis Gonzalez Palma, courtesy

Index